sleeveface

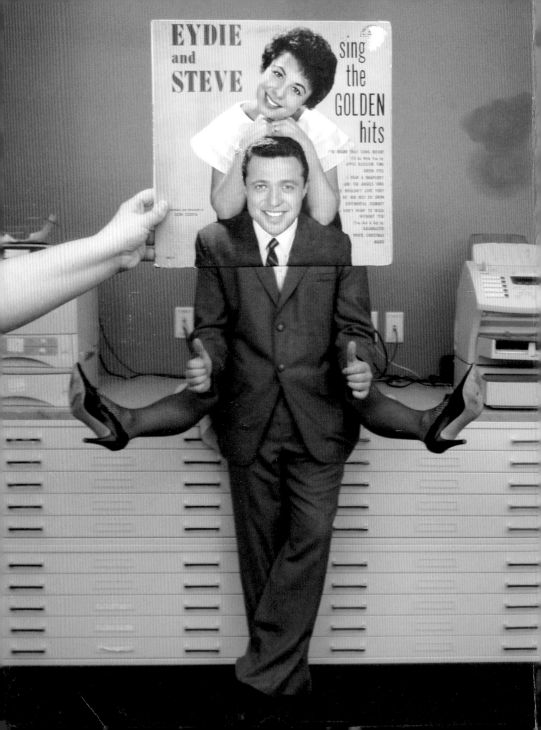

sleeveface

CARL MORRIS & JOHN ROSTRON

ARTISAN

This book contains a selection of Sleeveface photos. Each one has enough credits that you could even reenact the exact scene. But it's obviously more fun to think of your own. If you do want to hunt down a particular featured record, it's worth remembering that it may also be available with different artwork on a different record label, perhaps from a different country. Any credits we give here refer to the specific copy of the record used in the photo.

Typically no digital image tweaking is permitted, either using Photoshop or any other means. It just seems a bit like cheating. Sleeveface is a nondigital way of doing your image manipulation. So please have some low-tech fun manipulating your image.

For even more inspiration, search online for the short film series "How to Sleeveface."

Front cover: Reproduced by permission of Bob Hund, Silence records, and the album designer Martin Kann. www.myspace.com/bobhundofficial; www.silence.se; www.martinkann.com. Front cover photograph by Gunnar Bangsmoen.

Back cover: The image of Saunders Lewis by Jac Jones and the album for *Goreuon Sain* are reproduced by permission of Sain (Recordiau) Cyf [Atgynhyrchir y llun o Saunders Lewis gan Jac Jones, a chlawr *Goreuon Sain* drwy ganiatad Sain (Recordiau) Cyf].

Frontispiece: Eydie and Steve, *Eydie and Steve Sing the Golden Hits*, ABC-Paramount, 1960 Photograph by Jan Derevjanik, Crystal Bahmaie, Darren Haggar, and Stephanie Huntwork

Opposite: Elvis Presley, *Guitar Man*, RCA, 1969 Photograph by Monika Dabrowski

Published by Artisan
A Division of Workman Publishing Company, Inc.
225 Varick Street
New York, NY 10014-4381
www.artisanbooks.com

Library of Congress Control Number: 2008925221

ISBN-13: 978-1-57965-379-8

Design by Stephanie Huntwork

Printed in the United States
First printing, September 2008

10 9 8 7 6 5 4 3 2 1

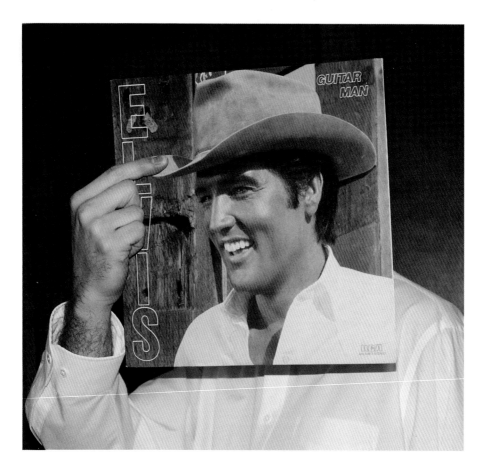

Can you judge a book by its cover? Just as a book has a cover, a record has a sleeve. You definitely can't judge a record by its sleeve because some of the greatest records are wrapped in appalling sleeves. One such example is *Pet Sounds* by The Beach Boys: an all-time classic work marrying the wistful, harmonious longings of youth with a hasty snapshot involving a tribe of goats. Put it this way, we just spent more time looking up the collective noun for goats than they probably did taking that photo.

But this is a book about sleeves and how you *can* judge a record by its sleeve. You just need to disregard the music inside for a moment and look at the outside. That's 144 square inches of dazzling visual art (or 288 if you count the rear side as well), with the exception of *Metal Box* by Public Image Ltd., which has around 113 square inches of art on each side. But at the time of writing, we're yet to see a Sleeveface involving that one.

If you don't know what Sleeveface is, you must be one of those exceptionally rare people who reads the introduction of a book first. What are you waiting for—dive into the middle now and read these words later!

Let's come back to the music. It all starts with the music. In the record creation process, the artwork is often the last thing to be decided, so usually you'll experience an album in the reverse order to that of its creator. Which must mean that on your journey you would expect to meet somewhere in the middle. Perhaps somewhere between the end of side A and the start of side B, when you flip the record over. All this may explain why the best track is often the first one on side B.

Sleeveface started with the music. Our adventures began when we were DJing at a night club that we run in our hometown of Cardiff, Wales. I hid my face behind a record, made a pose, then John took a photo, and vice-versa. We rifled through our record boxes and took half a dozen great pictures. The first ones we dabbled with were *McCartney II* by Paul McCartney, *Cat Scratch Fever* by Ted Nugent, *Cymande* by Cymande, *Athens Ohio* by Solex, and various albums by David Bowie.

We defined Sleeveface as "one or more persons obscuring or augmenting any part of their body or bodies with record sleeve(s) causing an illusion."

These photos went onto our fledgling Web site, sleeveface.com, as a way to share them with our friends. They seeped onto online photo galleries, blogs, and social networking sites. Much ink has been spilled about social networking—on modern society's twin anxieties of anonymity and attention seeking. But to summarize the story, loads of people saw it on the Internet, got excited, and joined in the fun.

We like vinyl. We appreciate music on other formats too, but vinyl has an intrinsic beauty, don't you think? Besides, vinyl is just bigger. For us, the meaning of Sleeveface has come to include the use of anything as a mask to cause an illusion, such as a book, CD, or magazine. Or perhaps even the vinyl disk itself—both sides, face value, no jacket required.

Every day we open our e-mail to see new and surprising Sleevefaces sent to us from all over the world. They make us smile, they make other Sleevefacers smile, and we hope they make you smile too.

—Carl Morris & John Rostron, 2008

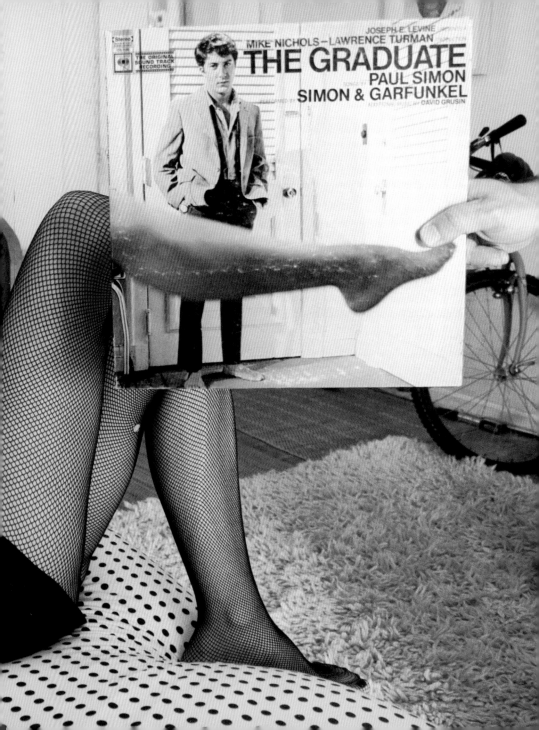

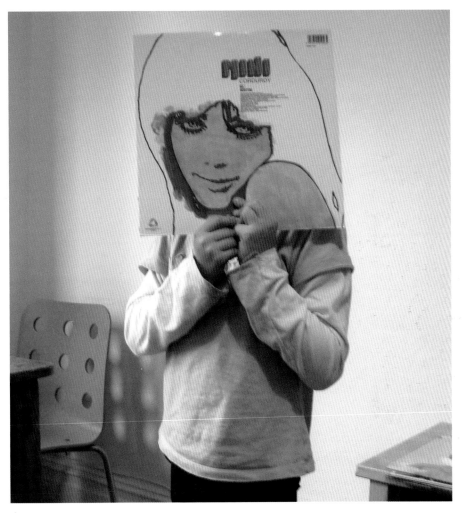

⌃ **Corduroy**, Mini, Acid Jazz, 1994
Photograph by Christophe Gowans

≪ **Simon and Garfunkel**, The Graduate, OST Columbia, 1967
Photograph by Crystal Bahmaie, Kathleen Lorden, and Johnny Reno

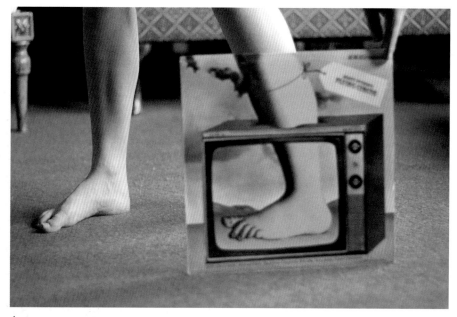

˄ Monty Python's Flying Circus, Monty Python's Flying Circus, BBC Records, 1970
Photograph by Alice Day

>> Barbra Streisand, Barbra Streisand's Greatest Hits Volume 2, CBS, 1978
Photograph by Christophe Gowans

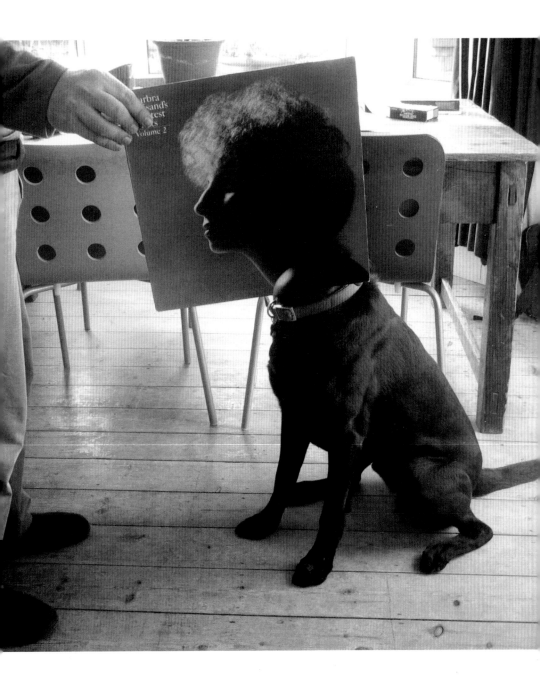

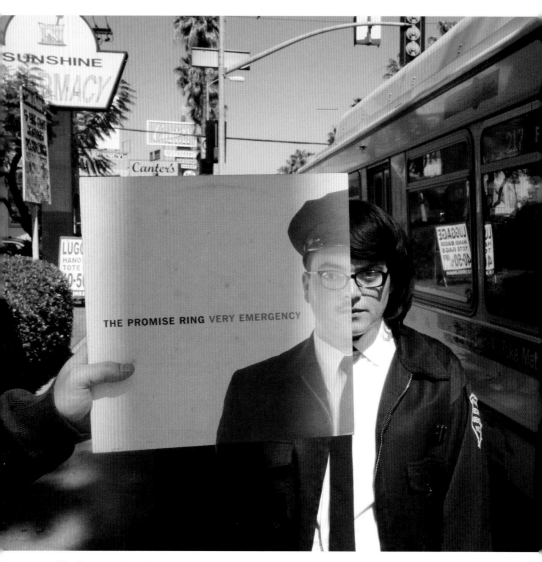

The Promise Ring, *Very Emergency*, Jade Tree, 1999
Photograph by Crystal Bahmaie, Kathleen Lorden, and Johnny Reno

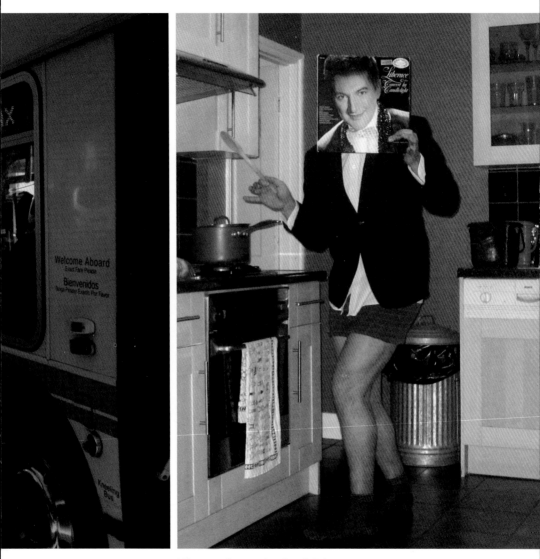

Liberace, Concert by Candlelight, Hallmark, 1966
Photograph by Christophe Gowans

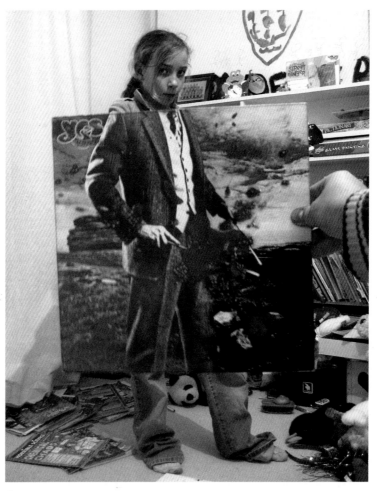

⌃ **Yes,** Tormato, Atlantic, 1978
Photograph by Christophe Gowans

≫ **Edith Piaf,** The Great Edith Piaf, Columbia, n.d.
Photograph by Robin Beever

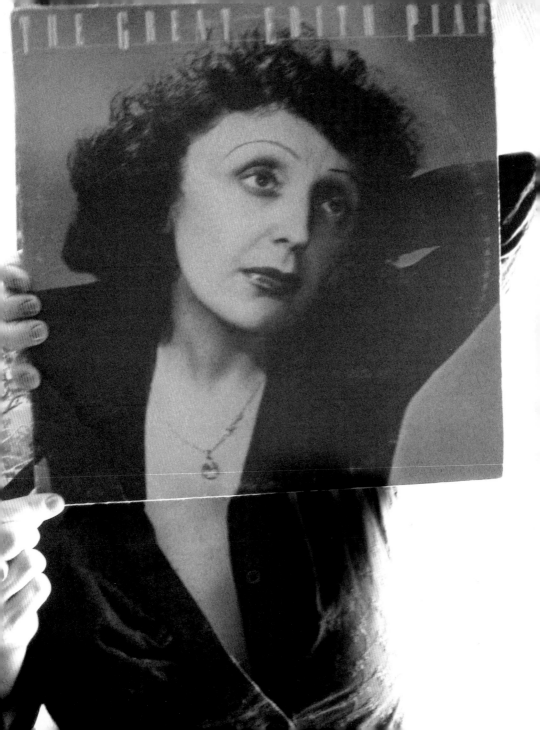

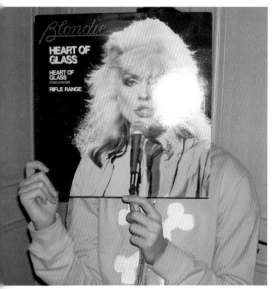

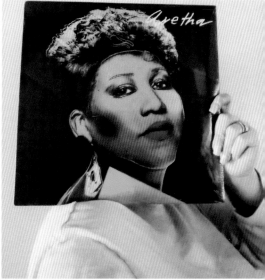

Blondie, Heart of Glass, Chrysalis, 1978
Photograph by Michelle-Brierley Davies

Aretha Franklin, Aretha, Arista, 1986
Photograph by Regina Migliorini

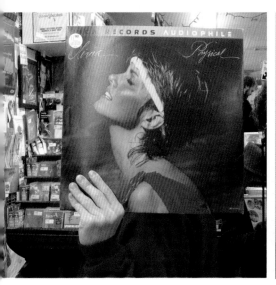

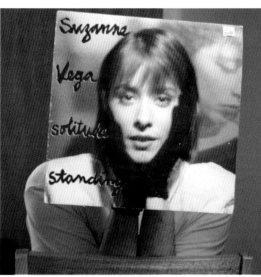

Olivia Newton John, Physical,
MCA Records, 1981
Photograph by Gabriel Kuo

Suzanne Vega, Solitude Standing, A&M, 1987
Photograph by Anthony Casey

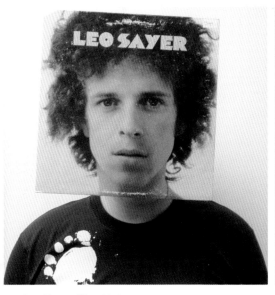

Leo Sayer, Silverbird, Chrysalis, 1973
Photograph by Anthony Skelton

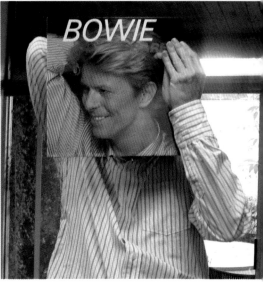

David Bowie, Rare, RCA ,1982
Photograph by Brian Robson

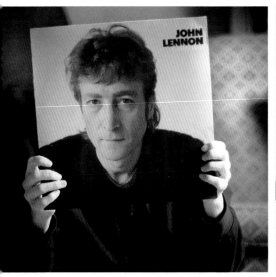

John Lennon, The John Lennon Collection,
EMI, 1982
Photograph by Alice Day

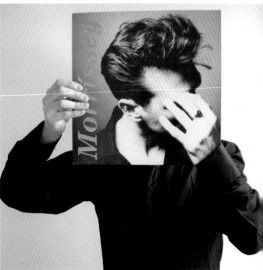

Morrissey, Every Day Is Like Sunday,
His Master's Voice (EMI), 1988
Photograph by Sheenagh and Mark James

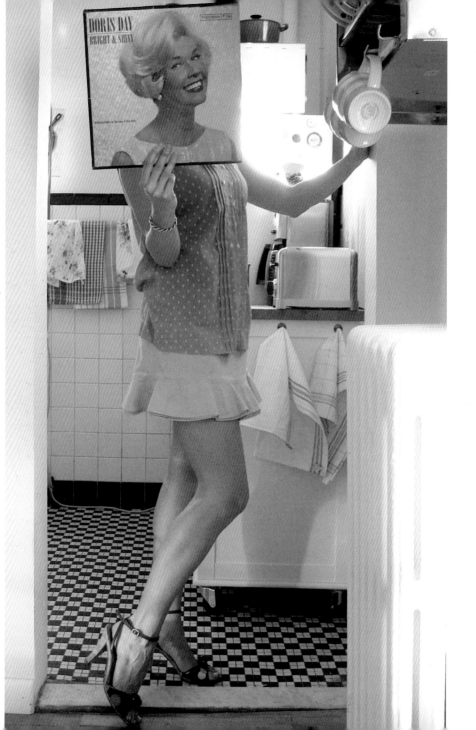

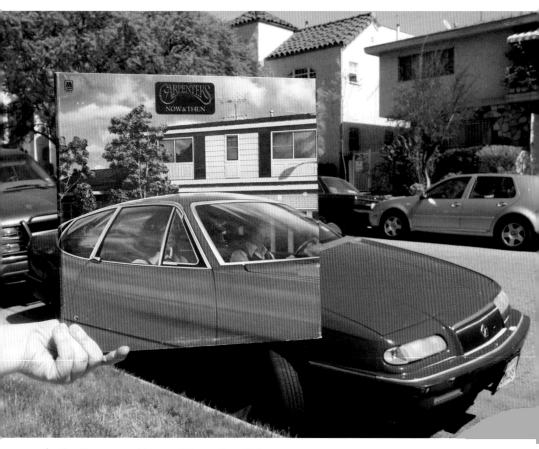

∧ **The Carpenters,** Now and Then, A&M, 1973
Photograph by Crystal Bahmaie, Kathleen Lorden, and Johnny Reno

<< **Doris Day**, Bright and Shiny, Columbia, 1961
Photograph by Darren Haggar and Stephanie Huntwork

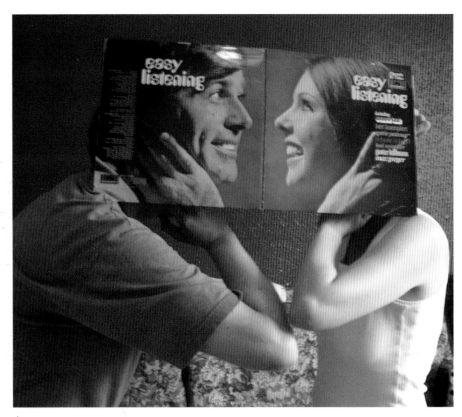

˄ **Various,** Easy Listening, Polydor, n.d.
Photograph by Ben Valentine Trow

>> INXS, Kick, Mercury/Atlantic 1987
Photograph by Tom Megginson

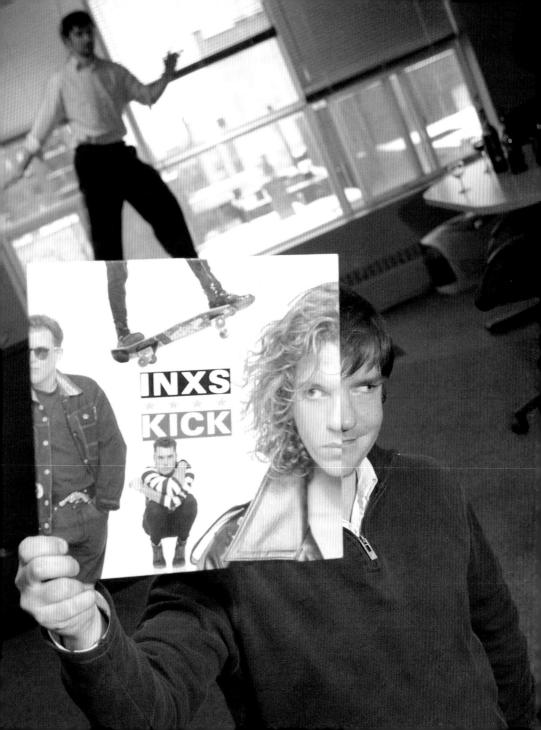

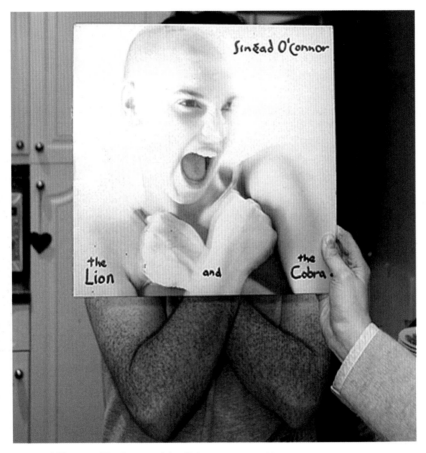

Sinéad O'Connor, The Lion and the Cobra, Chrysalis, 1987
Photograph by Martin Carr

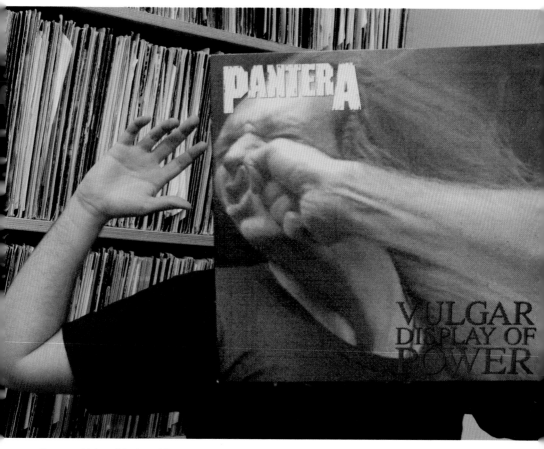

Pantera, Vulgar Display of Power, Atco (Atlantic), 1992
Photograph by Henry Covey

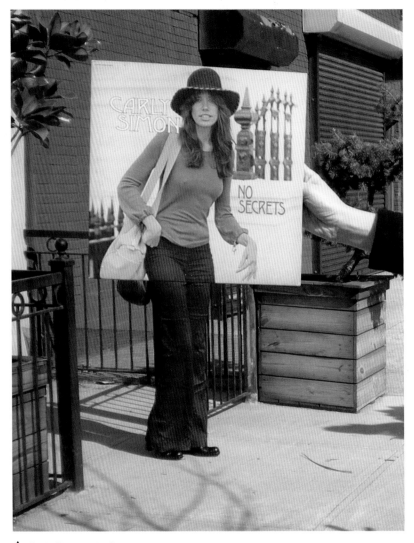

∧ **Carly Simon**, No Secrets, **Elektra, 1972**
Photograph by Chloe Godwin, Megan Nicolay, and Luke Janka

>> **Rod Stewart**, A Night on the Town, **Warner Brothers, 1976**
Photograph by Fionna McKerrell

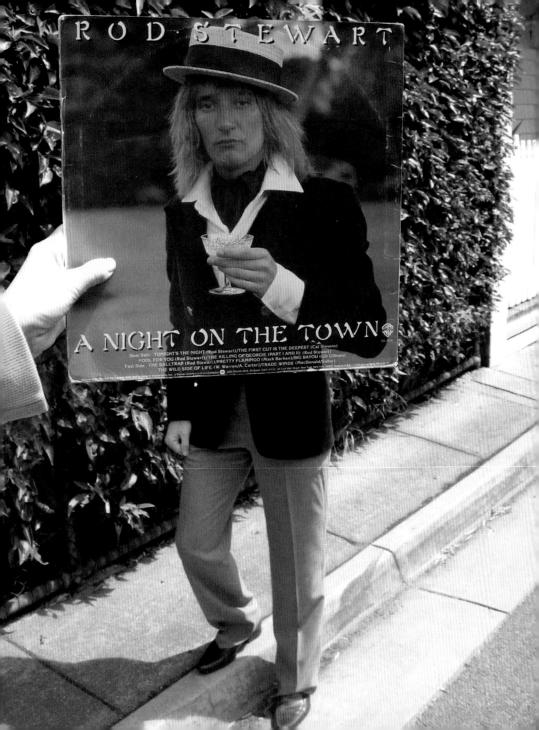

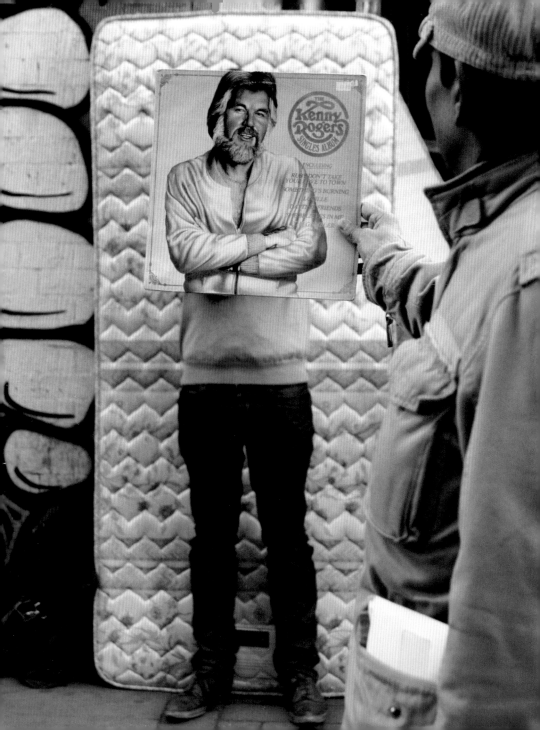

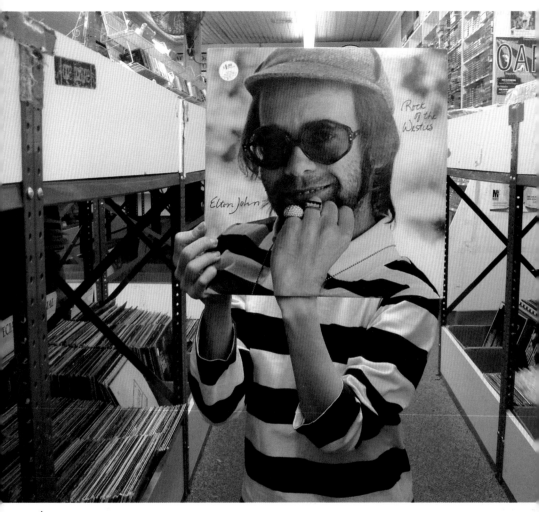

˄ **Elton John**, Rock of the Westies, MCA Records, 1975
Photograph by Gabe Kuo

« **Kenny Rogers**, The Kenny Rogers Singles Album, United Artists, 1978
Photograph by Ewan Jones Morris and Mark Bass

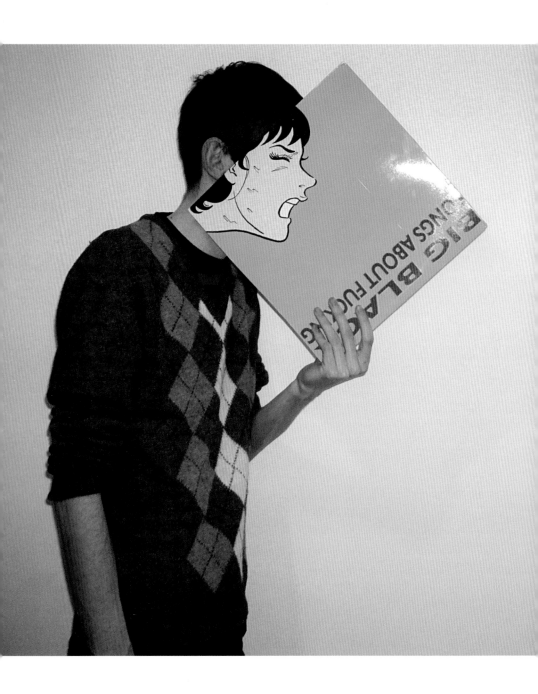

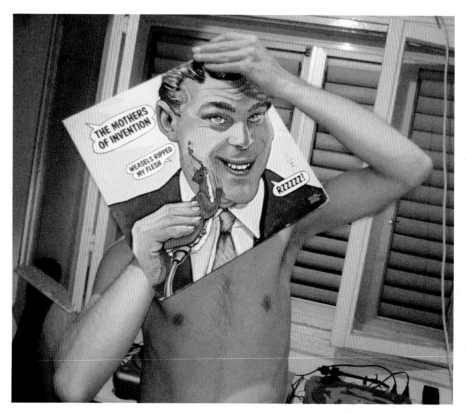

∧ **Frank Zappa,** Weasels Ripped My Flesh, Bizarre/Reprise, 1970
Photograph by Leon Feldman

≪ **Big Black,** Songs About Fucking, SST, 1987
Photograph by Ben Potter

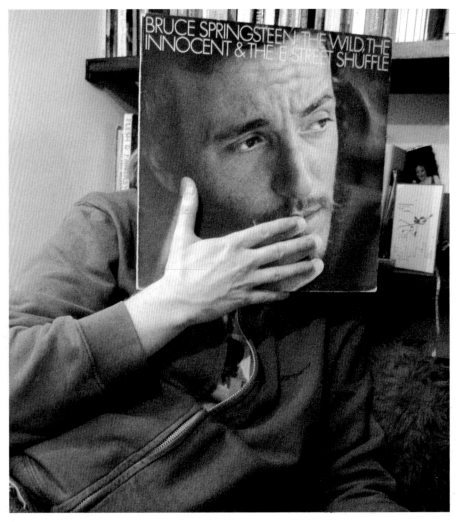

ʌ **Bruce Springsteen,** The Wild the Innocent and the E Street Shuffle, Columbia, 1973
Photograph by Fern Miller

>> **Bruce Springsteen,** Born in the U.S.A., Columbia, 1984
Photograph by Chloe Godwin, Megan Nicolay, and Luke Janka

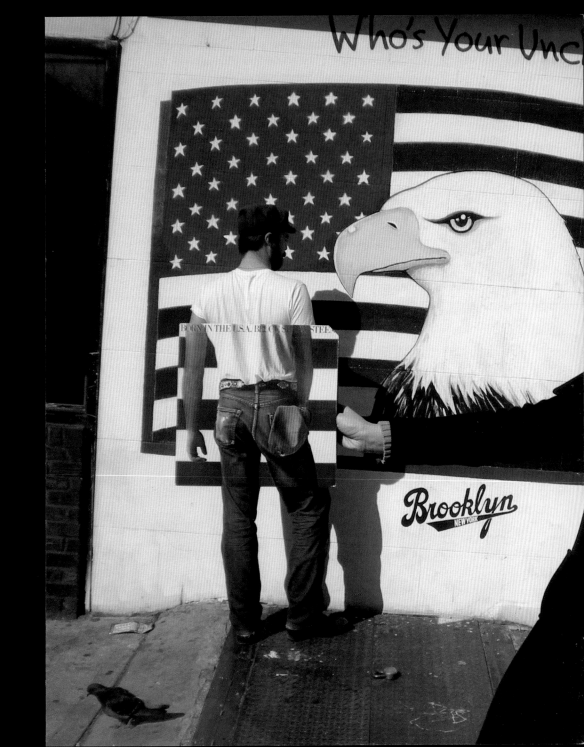

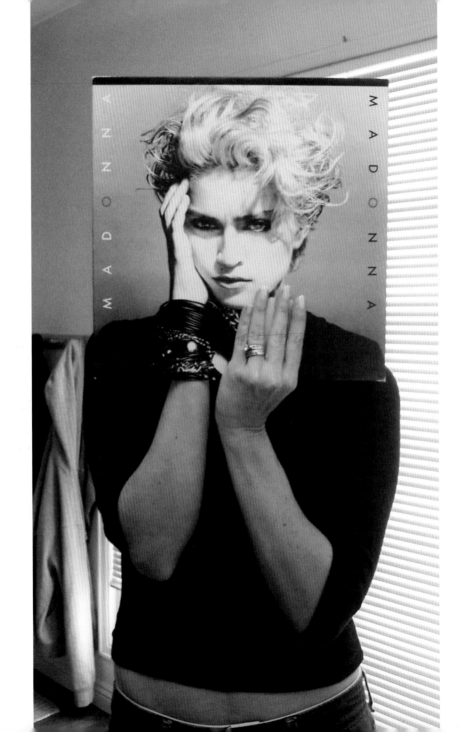

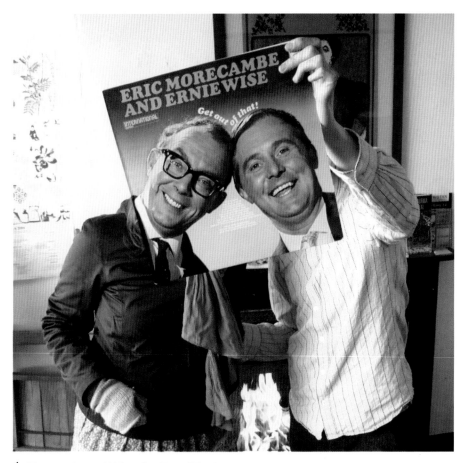

^ **Morecambe and Wise**, Get Out of That!, Philips, 1970
Photograph by David Hopkinson

<< **Madonna**, Madonna, Sire, 1983
Photograph by Annie Spencer

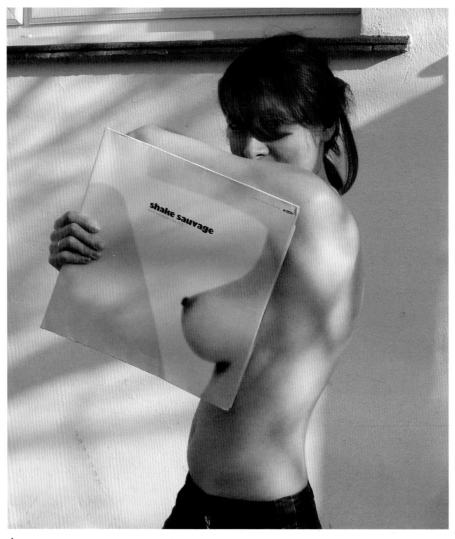

∧ **Various,** Shake Sauvage: French Soundtracks 1968–1973,
Crippled Dick Hot Wax, 2000
Photograph by Rebecca Newman

≫ **Elvis Costello & the Attractions,** Trust, Columbia, 1981
Photograph by Crystal Bahmaie, Kathleen Lorden, and Johnny Reno

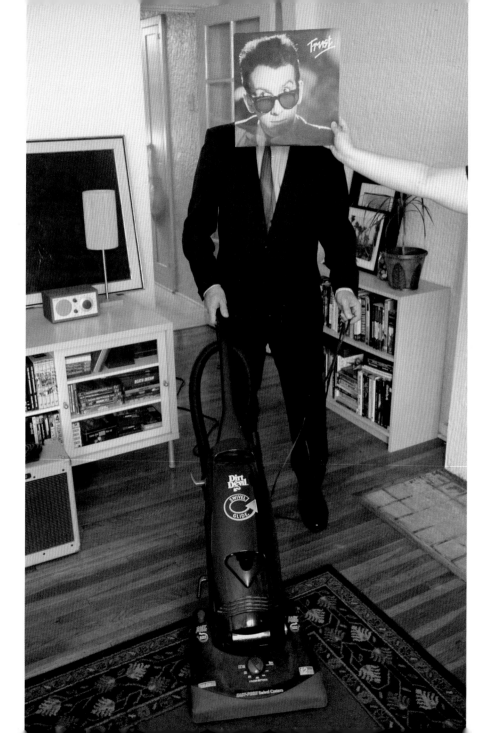

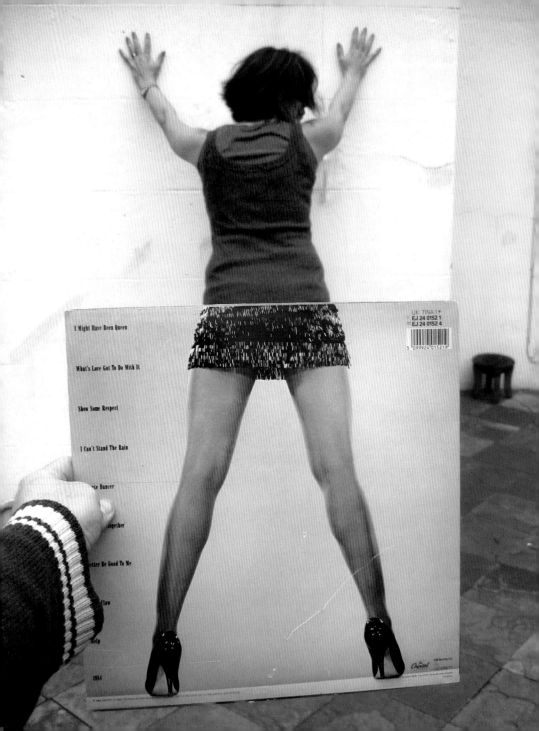

I Might Have Been Queen

What's Love Got To Do With It

Show Some Respect

I Can't Stand The Rain

...te Dancer

...gether'

...tter Be Good To Me

...flaw

...elp

1984

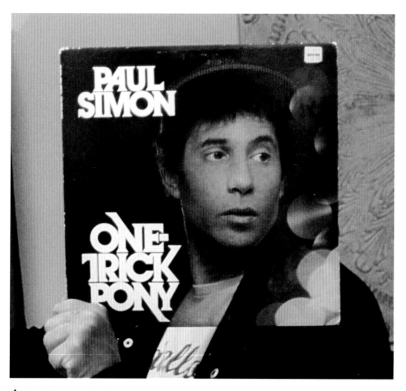

∧ **Paul Simon,** One-Trick Pony, Warner Brothers, 1980
Photograph by Coke Brown Jr.

≪ **Tina Turner,** Private Dancer, Capitol, 1984
Photograph by Christophe Gowans

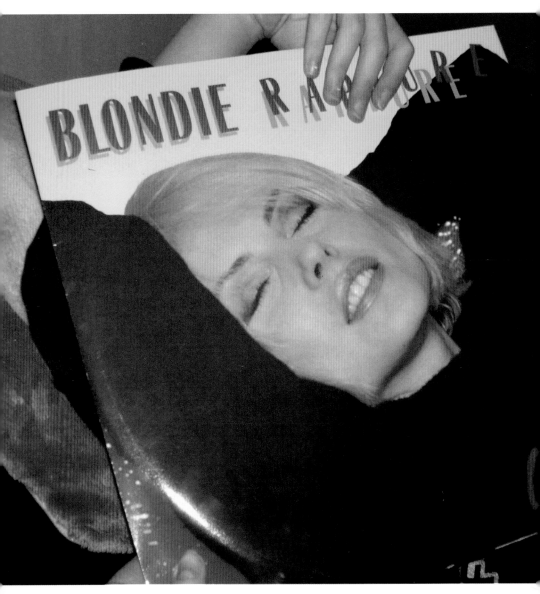

Blondie, Rapture, Chrysalis, 1981
Photograph by Michelle-Brierley Davies

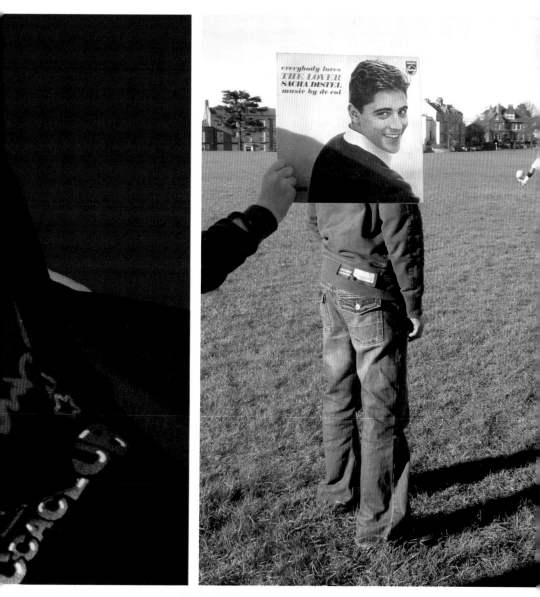

Sacha Distel, Everybody Loves the Lover, Philips, 1961
Photograph by Christophe Gowans

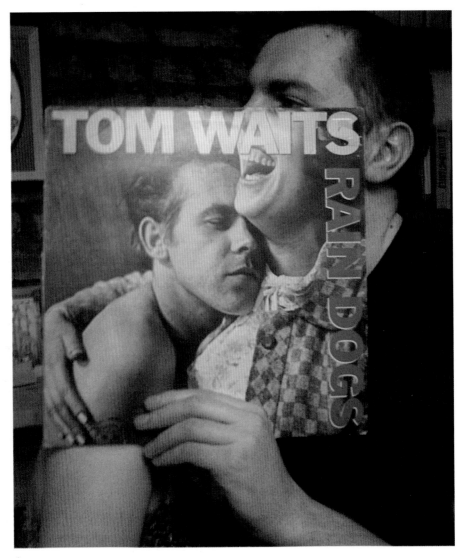

ᐱ Tom Waits, Rain Dogs, Island, 1985
 Photograph by Emma Cardwell

≫ Lou Reed, Lou Reed Live, RCA, 1975
 Photograph by Sophie Nicolay, Megan Nicolay, and Luke Janka

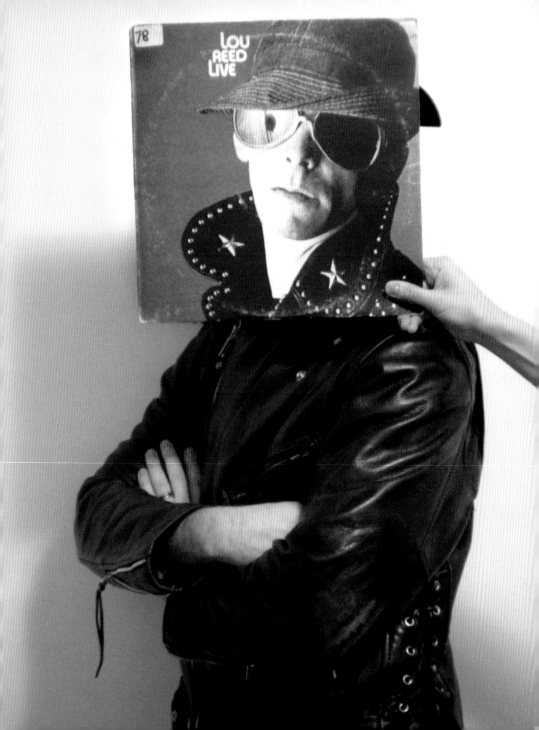

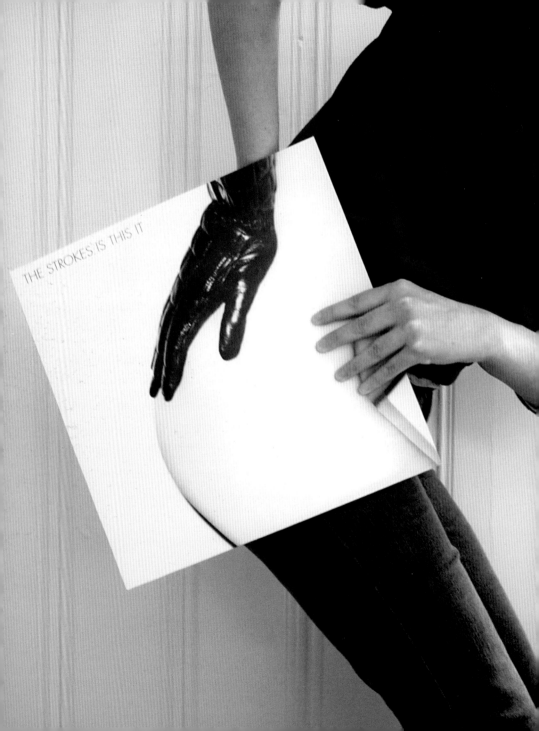

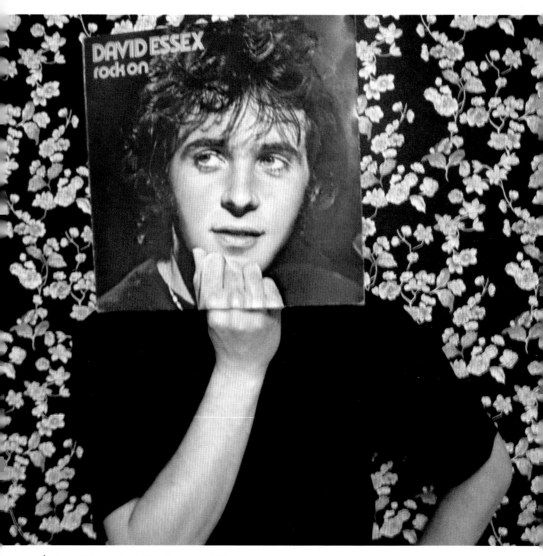

∧ **David Essex,** Rock On, Columbia, 1974
Photograph by Graeme Swinton

<< **The Strokes,** Is This It, BMG, 2001
Photograph by Gunnar Bangsmoen

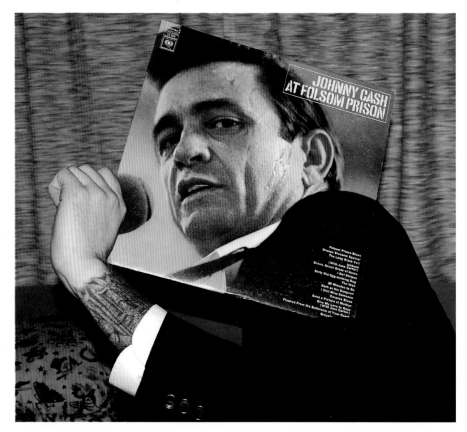

∧ **Johnny Cash,** At Folsom Prison, Columbia, 1968
Photograph by Monika Dabrowski

≫ **Rod Stewart,** A Night on the Town, Warner Brothers, 1976
Photograph by Steve McConville

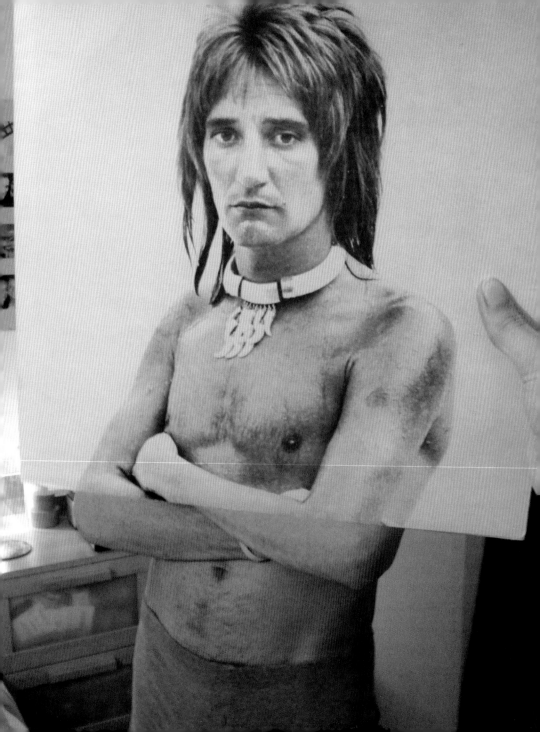

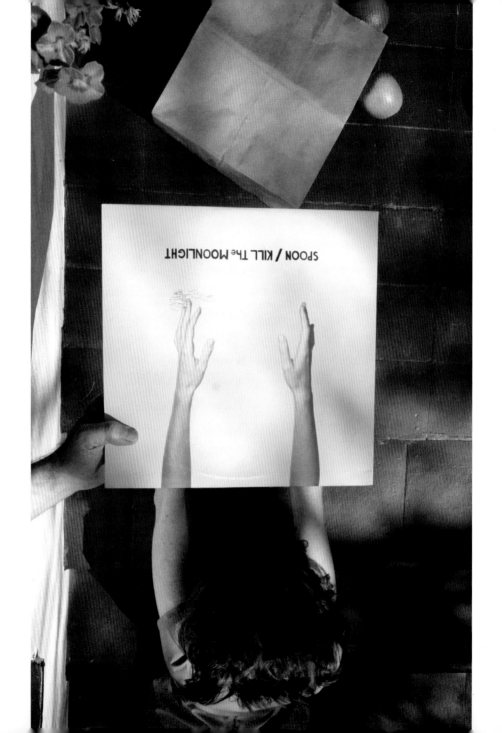

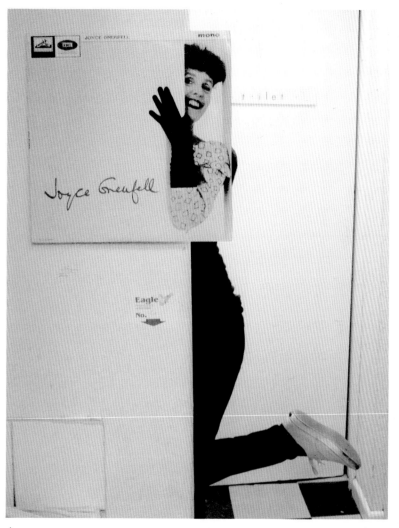

⌃⌃ **Joyce Grenfell,** Joyce Grenfell, His Masters Voice (EMI), 1964
Photograph by David Hopkinson

<< **Spoon,** Kill the Moonlight, Merge, 2002
Photograph by Crystal Bahmaie, Kathleen Lorden, and Johnny Reno

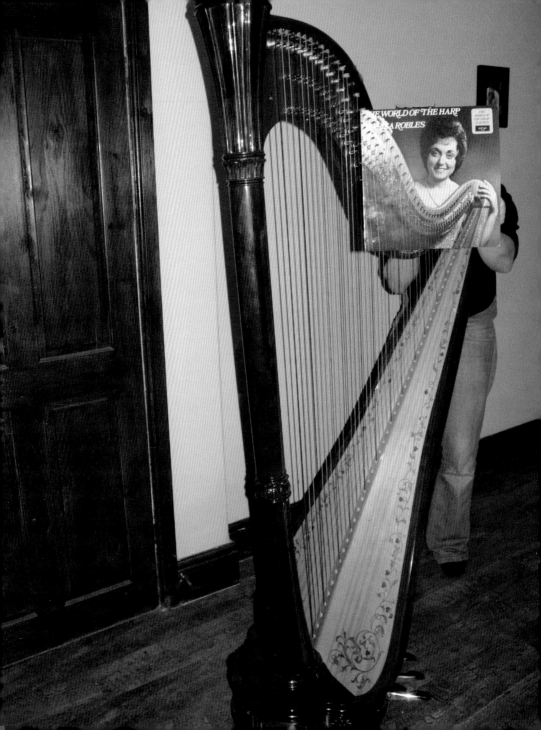

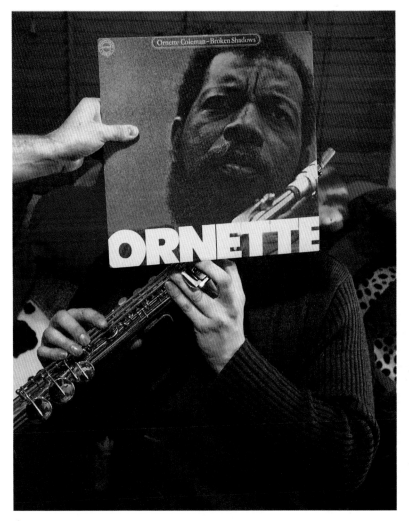

˄ **Ornette Coleman,** Broken Shadows, Columbia, 1982
Photograph by Martin Carr and Mary Wycherlcy

<< **Marisa Robles,** The World of the Harp, Decca, 1974
Photograph by Tim Morgan

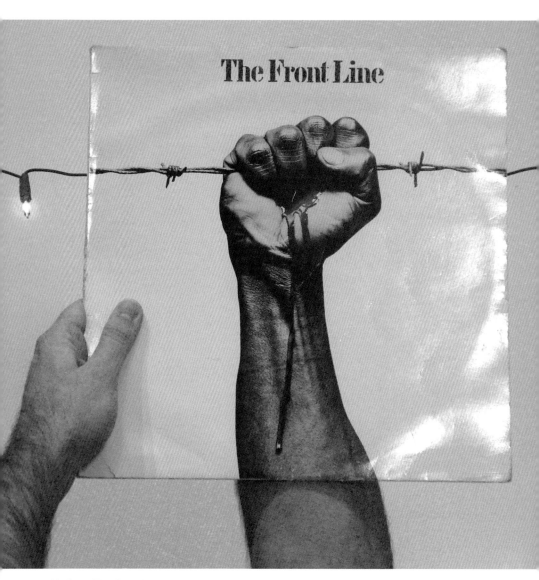

Various, The Front Line, Virgin, 1976
Photograph by Johnny Dbini and Tanja Raman

New Order, Low-Life, Factory, 1985
Photograph by Christophé Gowans

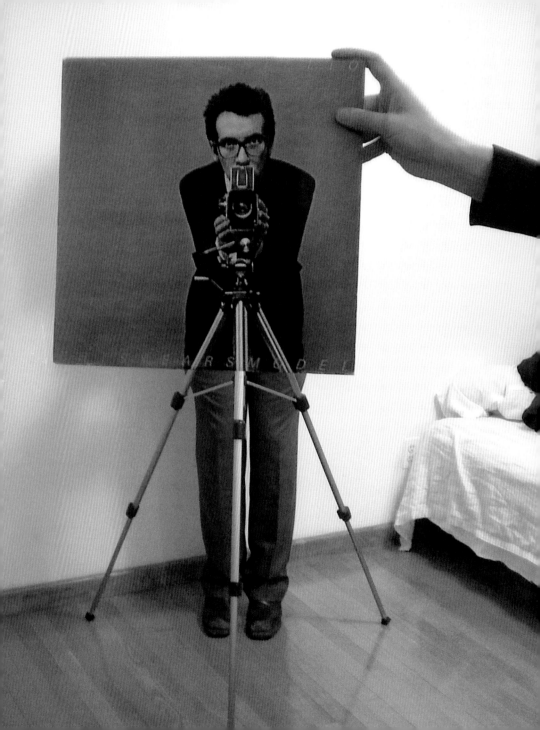

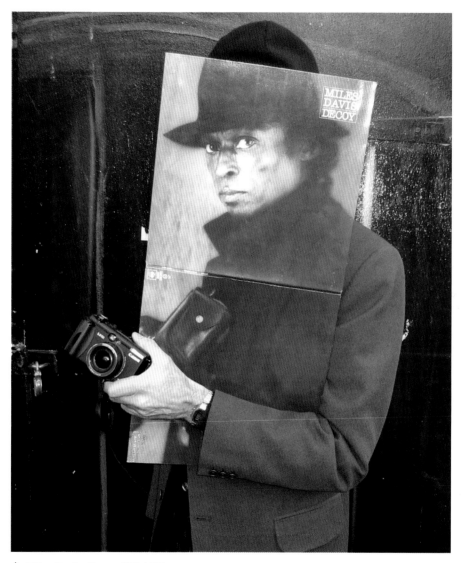

ʌ **Miles Davis,** Decoy, CBS, 1984
Photograph by Christophe Gowans

<< **Elvis Costello,** This Year's Model, Columbia, 1978
Photograph by Sophie Nicolay, Megan Nicolay, and Luke Janka

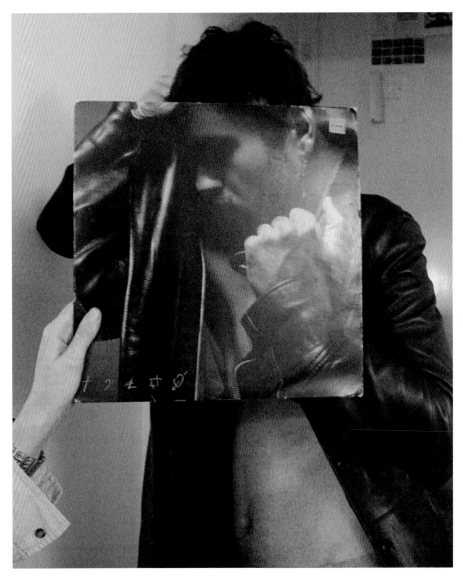

George Michael, Faith, Epic/CBS, 1987
Photograph by Steve McConville

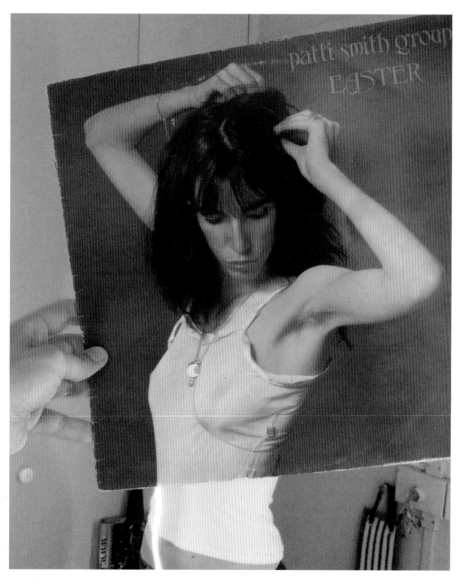

Patti Smith Group, Easter, Arista, 1978
Photograph by Lucas Latallerie

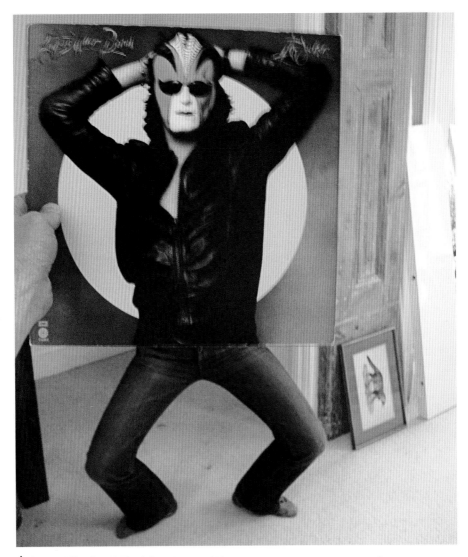

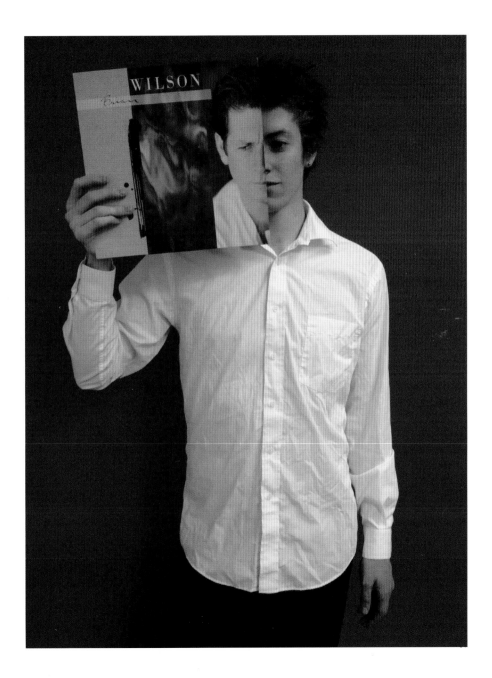

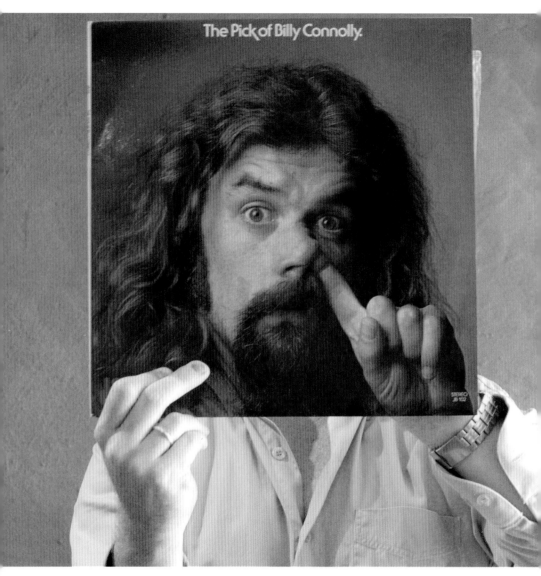

Billy Connolly, The Pick of Billy Connolly, Polydor, 1981
Photograph by Marcus Darbyshire

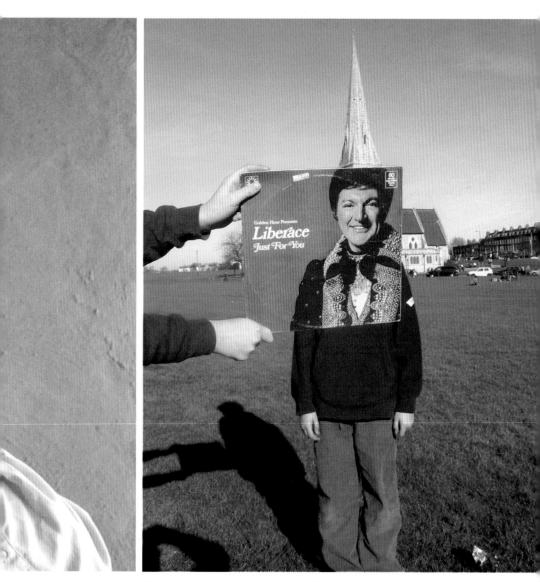

Liberace, Just for You, Golden Hour (PYE), 1976
Photograph by Christophe Gowans

Hydra, Land of Money, Capricorn, 1974
Photograph by Silje Solhaug

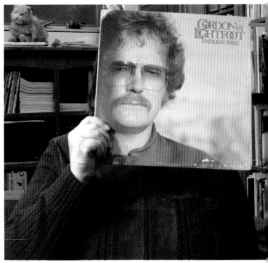

Gordon Lightfoot, Endless Wire, Warner Brothers, 1978
Photograph by Rick Hebenstreit

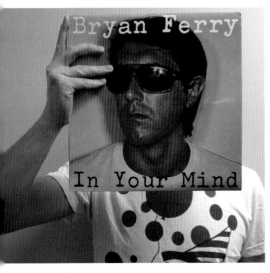

Bryan Ferry, In Your Mind, Polydor, 1977
Photograph by Graeme Swinton

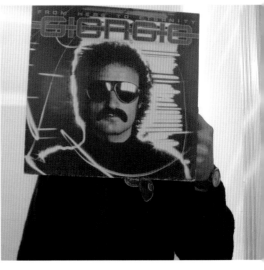

Giorgio Moroder, From Here to Eternity, Oasis, 1977
Photograph by Felix Steinbild

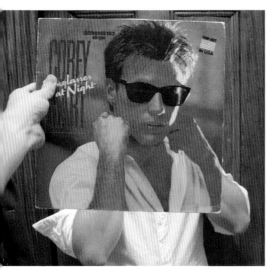

Corey Hart, Sunglasses at Night, EMI America, 1983
Photograph by Henry Covey

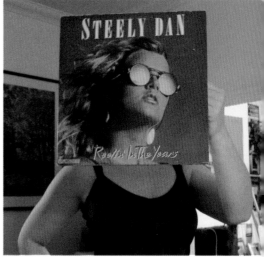

Steely Dan, The Very Best of Steely Dan—Reelin' in the Years, MCA Records, 1985
Photograph by Fern Miller

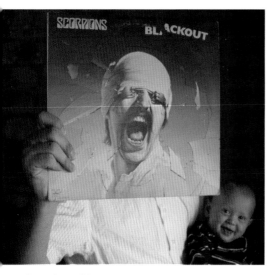

Scorpions, Blackout, Harvest/Mercury, 1982
Photograph by Christopher Stangland

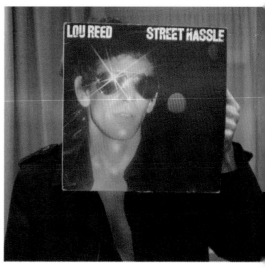

Lou Reed, Street Hassle, Arista, 1978
Photograph by Paul Barnett

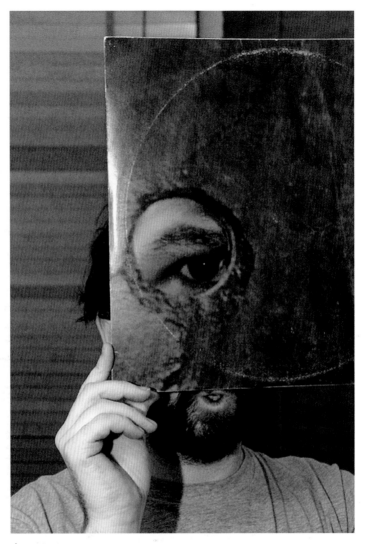

⌃ **Boom Bip & Doseone,** Circle, Mush, 2000
Photograph by Martin Carr

›› **John Travolta,** John Travolta, RCA Records, 1976
Photograph by Crystal Bahmaie, Jan Derevjanik,
Stephanie Huntwork, and Erin Sainz

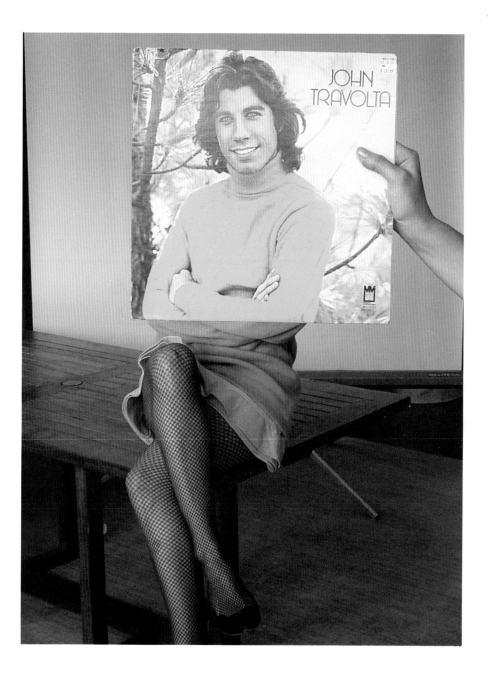

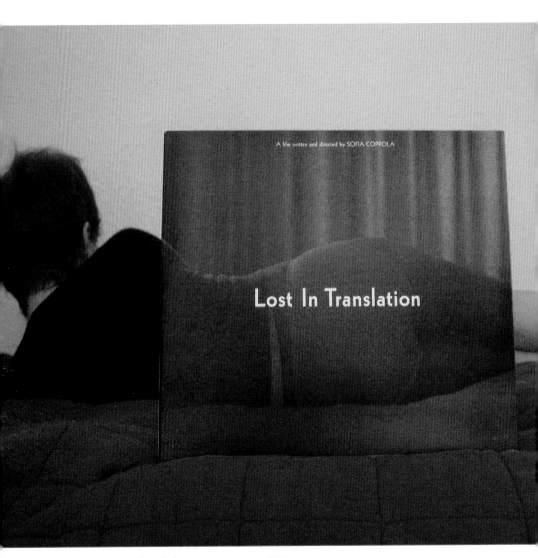

A film written and directed by SOFIA COPPOLA

Lost In Translation

Various, Lost in Translation, Emperor Norton, 2003
Photograph by Ian Watson

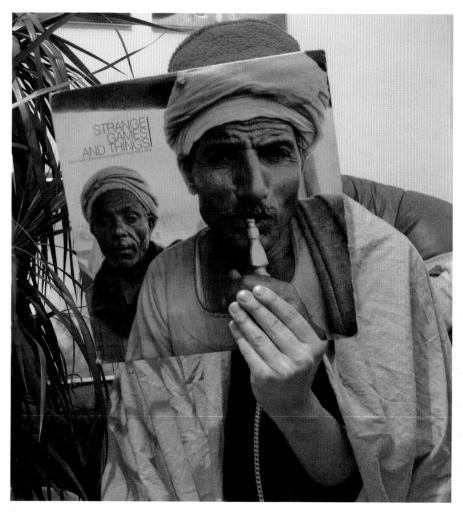

∧ **Various,** Strange Games and Things, BBE, 1997
Photograph by Felix Steinbild

<< **Serge Gainsbourg,** Love on the Beat, Phonogram, 1984
Photograph by Laurent Zac

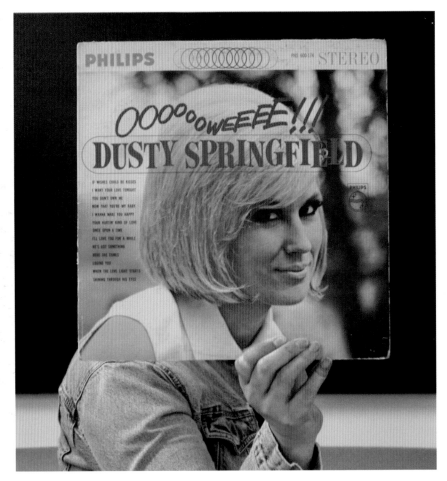

Dusty Springfield, Oooooooweeee!!, Philips, 1965
Photograph by Christopher Minney

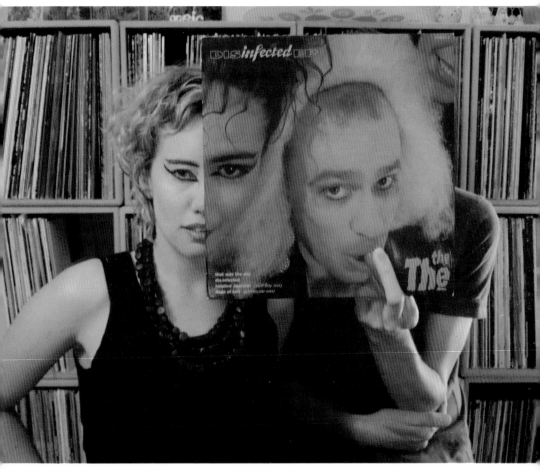

The The, Infected, Epic/CBS, 1986
Photograph by Lisa Heledd Jones

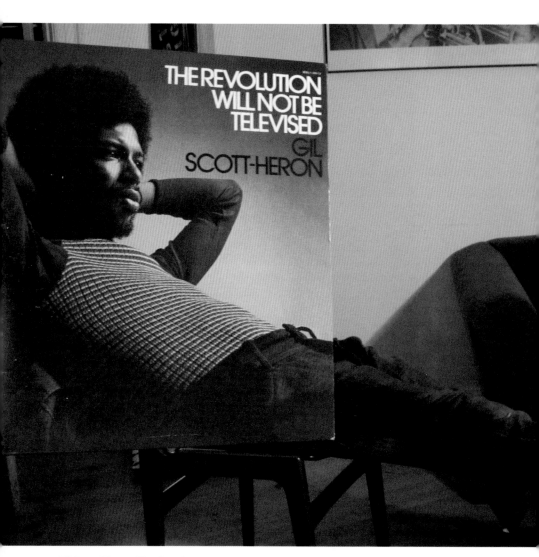

Gil Scott-Heron, The Revolution Will Not Be Televised, BMG, 1998
Photograph by Thomas Emil Christiansen

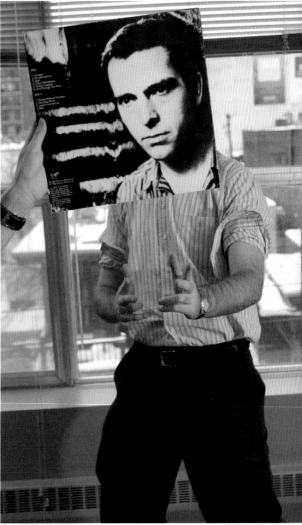

Peter Gabriel, 3, Charisma/Virgin, 1980
Photograph by Tom Megginson

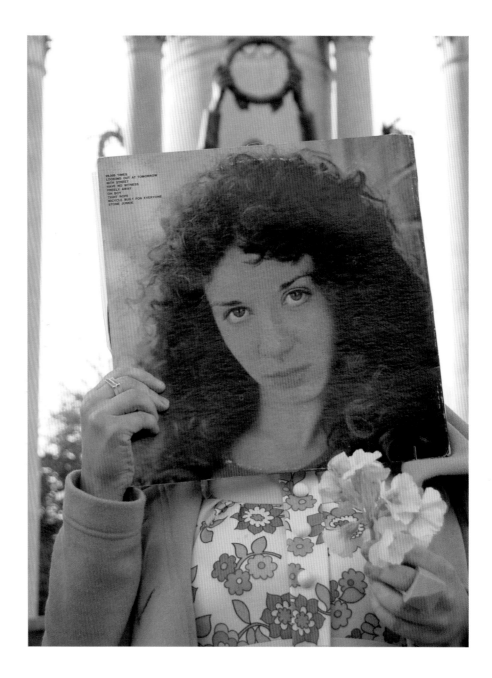

65,000 TIMES
LOOKING OUT AT TOMORROW
WITH STREET
HAVE NO WITNESS
FREELY AWAY
OH BOY
TIGHT ROPE
BICYCLE BUILT FOR EVERYONE
STONE JUNKIE

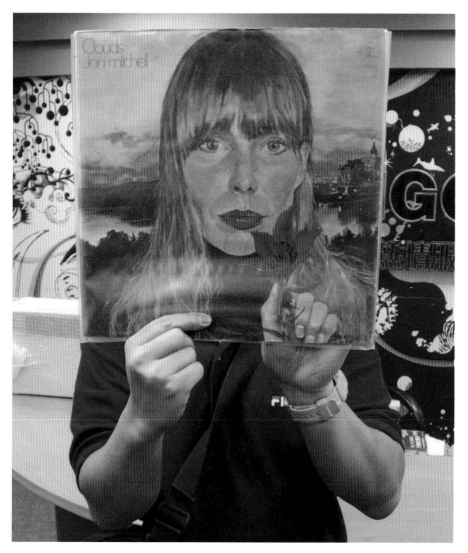

∧ **Joni Mitchell,** Clouds, Reprise, 1967
 Photograph by Vivian Heng and the Project Pimps

<< **Ruby Jones,** Ruby Jones, Curtom, 1971
 Photograph by Lisa Heledd Jones

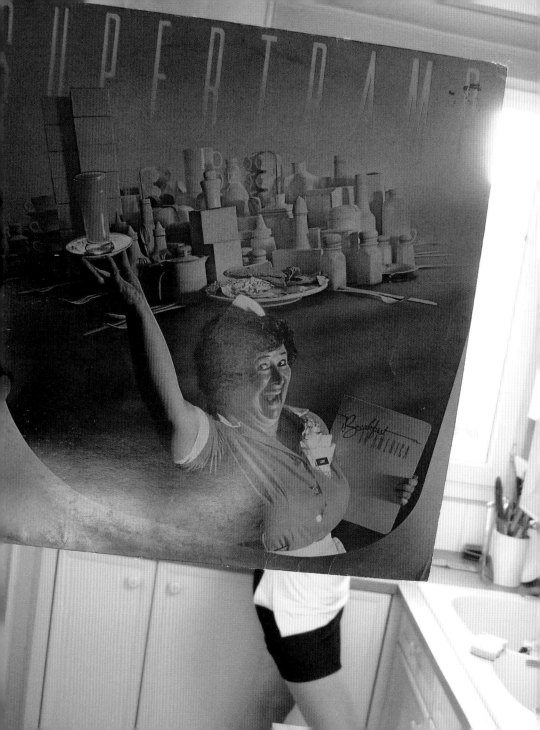

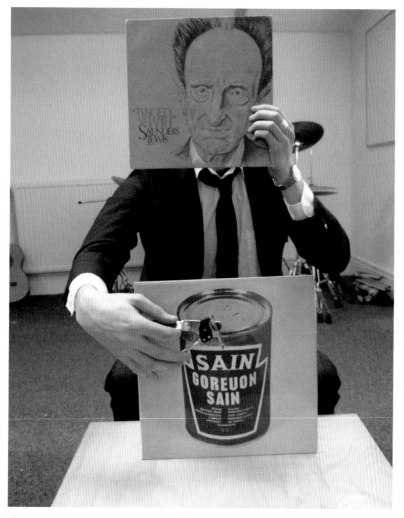

∧ **Saunders Lewis,** Tynged Yr Iaith, Sain, 1962

∧ **Various,** Goreuon Sain, Sain, n.d.
Photograph by John Rostron

≪ **Supertramp,** Breakfast in America, A&M, 1979
Photograph by Lucas Latallerie

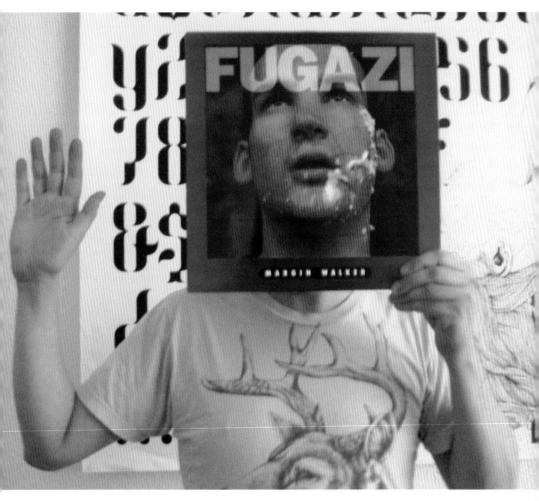

˄ **Fugazi,** Margin Walker, Dischord, 1989
Photograph by Ian Watson

<< **Frank Zander,** Zander's Zorn, Hansa, 1976
Photograph by Ewan Jones Morris and Kate Speiss

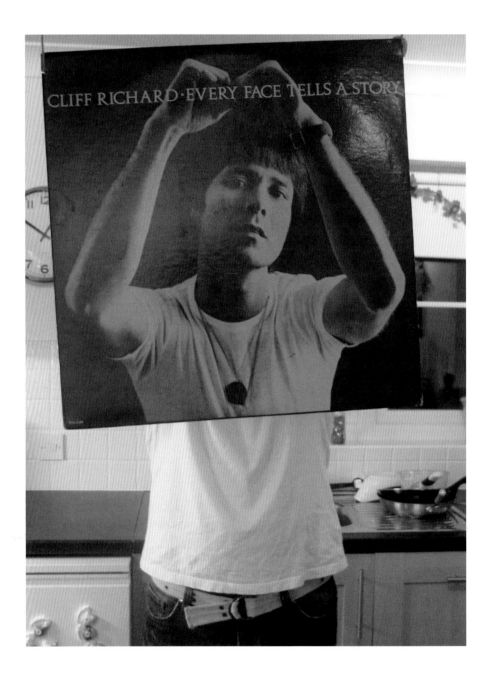

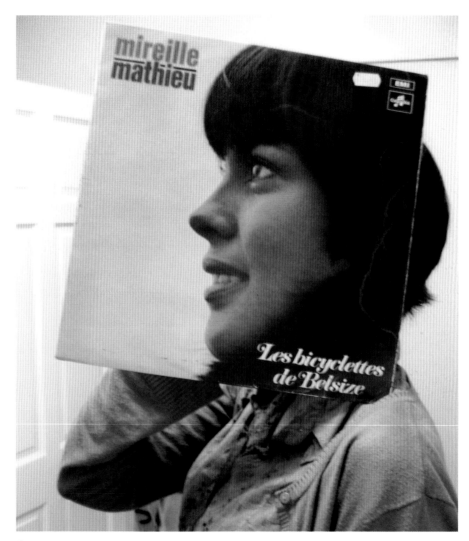

^ **Mireille Mathieu,** Les bicyclettes de Belsize, Columbia, 1968
Photograph by Nic Finch and Debbie Savage

<< **Cliff Richard,** Every Face Tells a Story, MCA Records, 1977
Photograph by Phil Harris

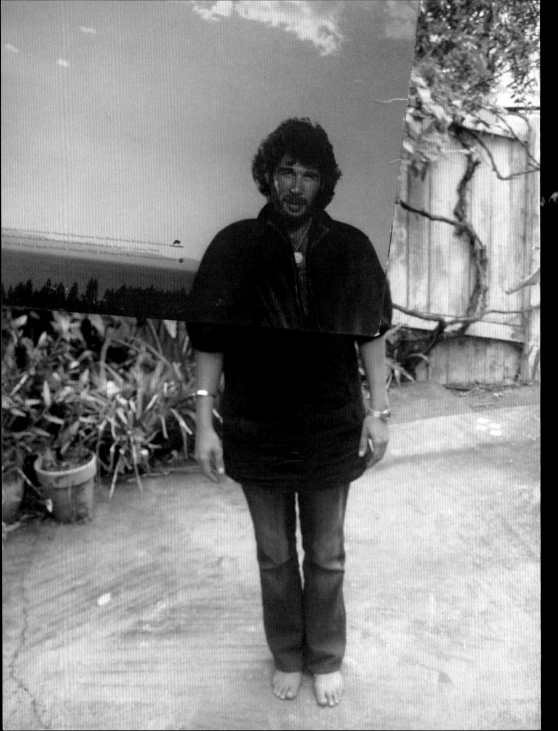

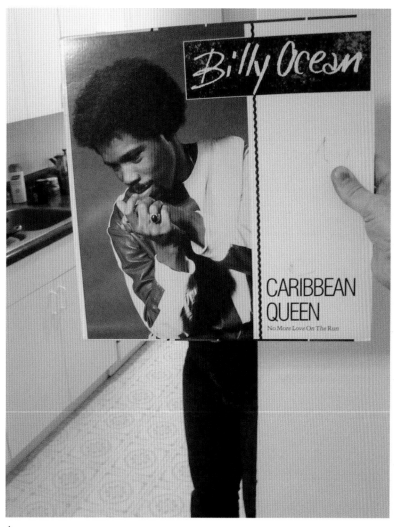

∧ **Billy Ocean,** Caribbean Queen, Arista, 1984
Photograph by John Kannenberg

<< **Eddie Rabbit,** The Very Best Of, Elektra/Asylum, 1979
Photograph by Matthew Straker

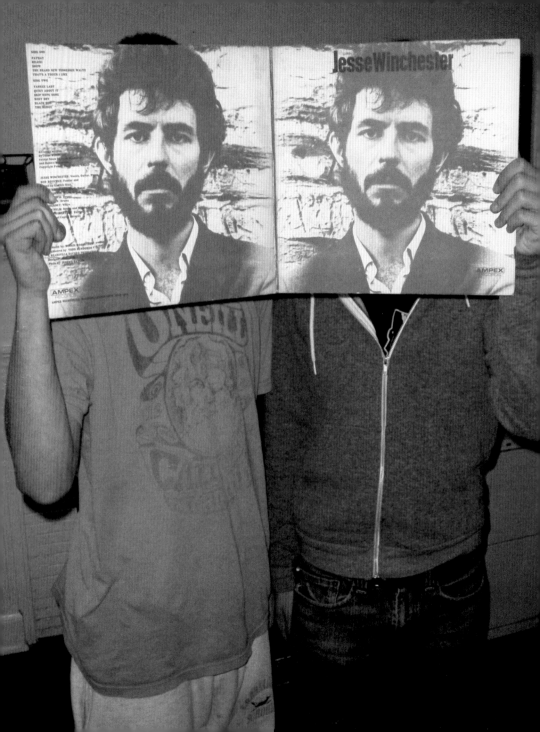

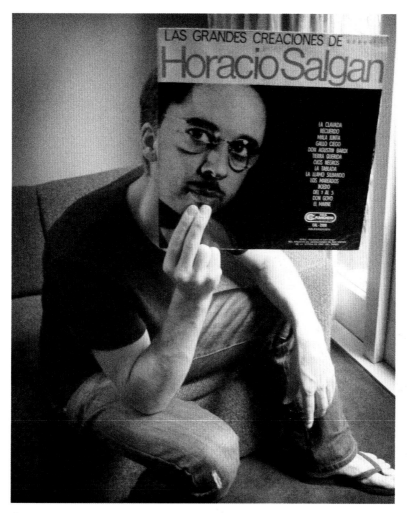

⌃ **Horacio Salgan,** Las Grandes Creaciones de Horacio Salgan, RCA, 1966
Photograph by Matthew Straker

<< **Jesse Winchester,** Jesse Winchester, Ampex, 1970
Photograph by Jonah Kagan

∧ **Devendra Banhart,** Heard Somebody Say, XL Recordings, 2005
Photograph by John Rostron

>> **Demis Roussos,** Forever and Ever, Philips, 1973
Photograph by Fiona McKerrell

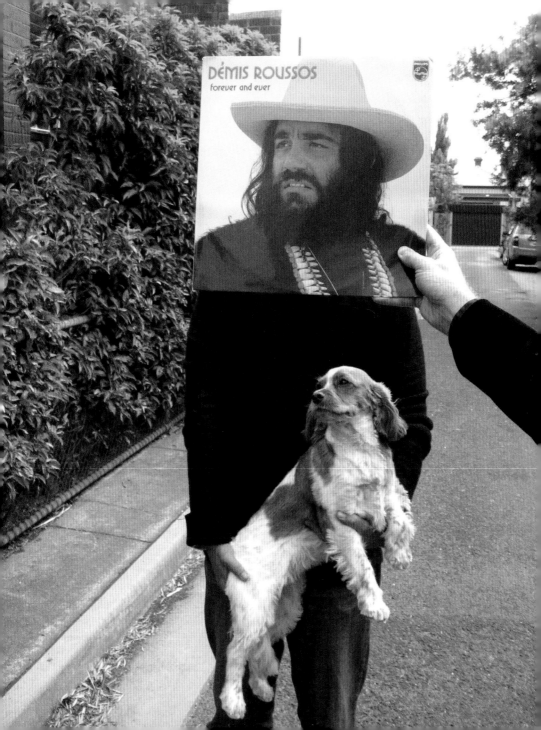

DÉMIS ROUSSOS
forever and ever

PHILIPS

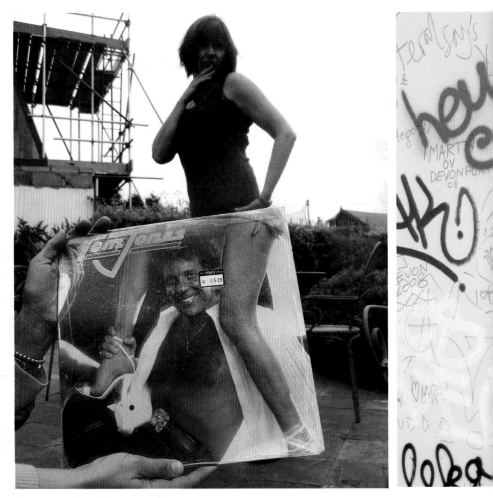

Tom Jones, Close Up, Decca, 1972
Photograph by Christophe Gowans

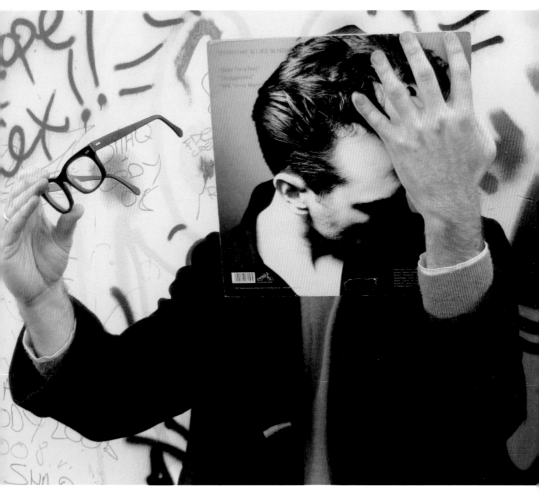

Morrissey, *Every Day Is Like Sunday,* His Master's Voice (EMI), 1988
Photograph by David Hopkinson

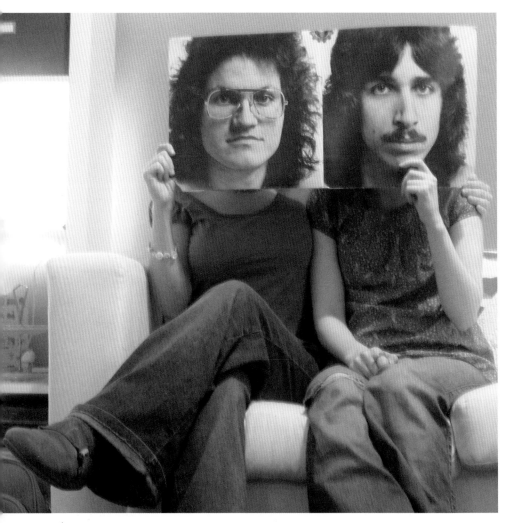

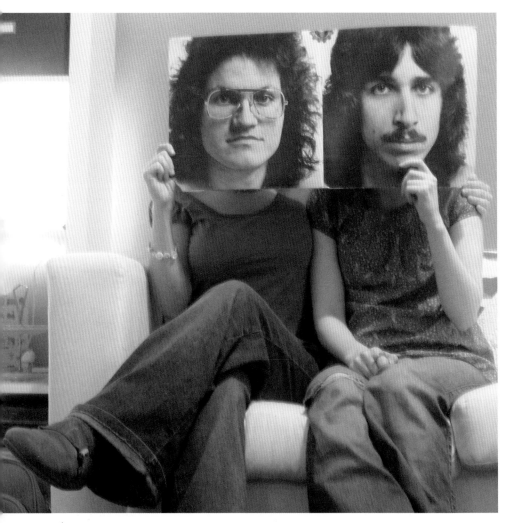 Bachman-Turner Overdrive, *Head On,* Mercury, 1975
Photograph by Anna-Marie McMahon

>> Bonnie "Prince" Billy, *Master and Everyone,* Domino, 2003
Photograph by Emma Cardwell

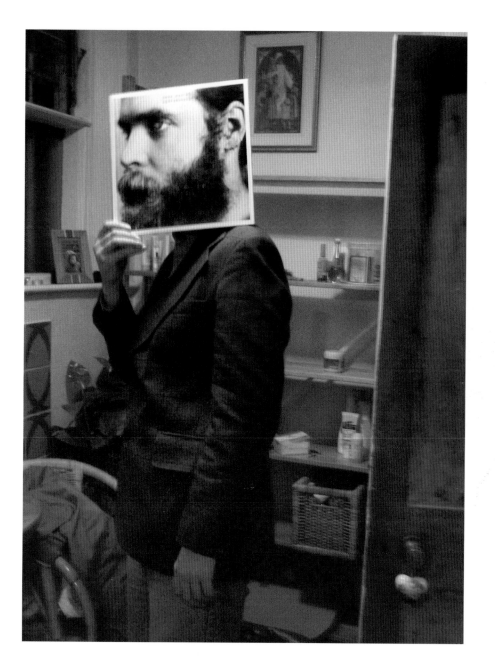

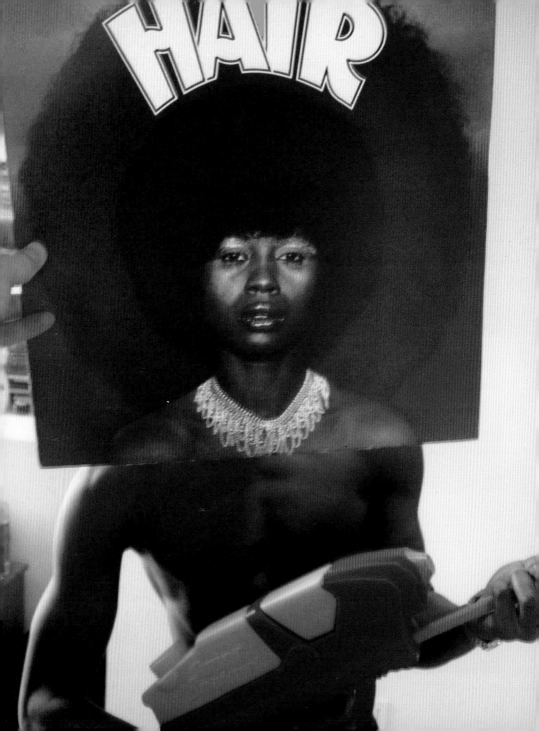

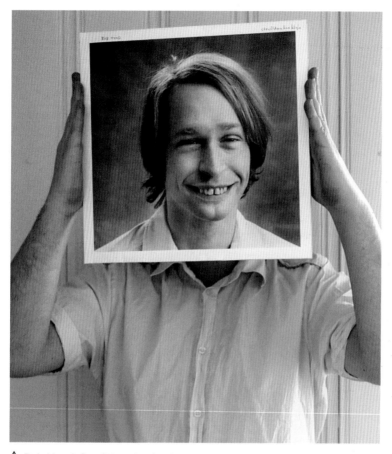

∧ **Bob Hund,** Stenåldern kan börja, Traxton recording &
Bob Hund Förlag, 2001
Photograph by Gunnar Bangsmoen

<< **Hair (Original London Cast),** Hair, Polydor, 1968
Photograph by Sophie Hostick

>> **Roxy Music,** The First Roxy Music Album, Atco (Atlantic), 1972
Photograph by Chloe Godwin and Megan Nicolay

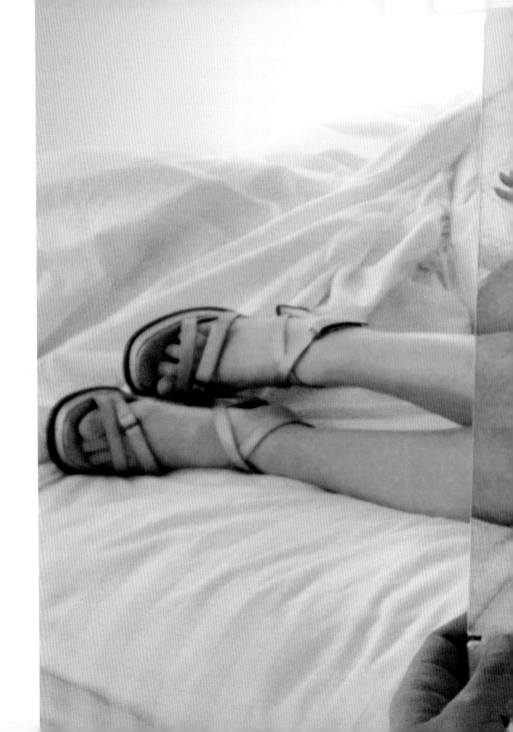

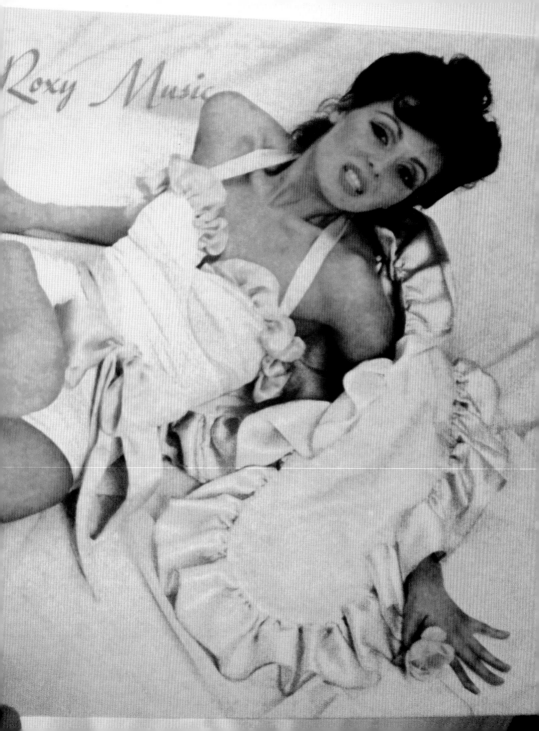

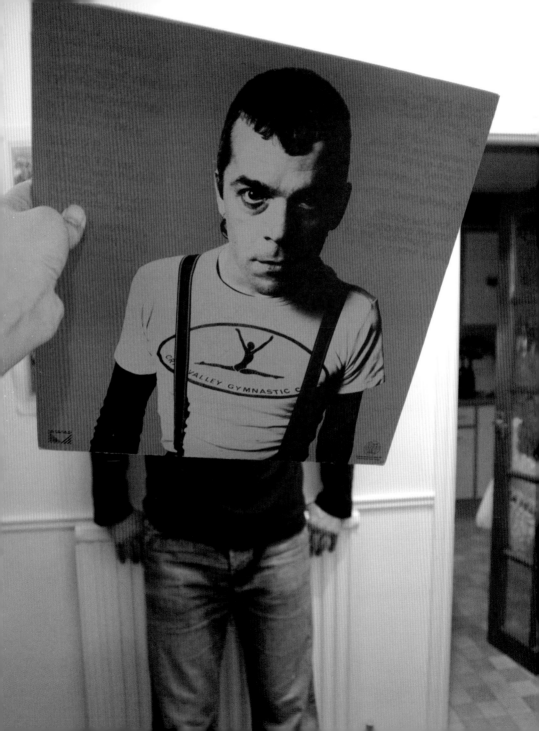

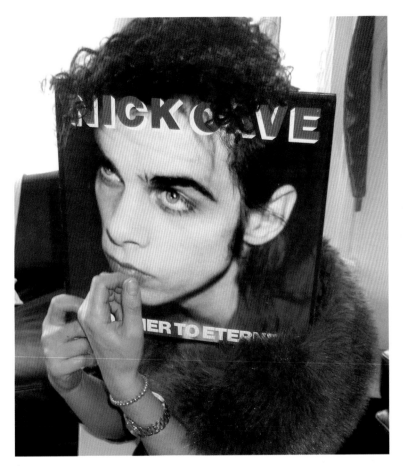

∧ **Nick Cave,** From Her to Eternity, Mute, 1984
Photograph by Christophe Gowans

<< **Ian Dury and the Blockheads,** New Boots and Panties, Stiff, 1977
Photograph by Sam Turley

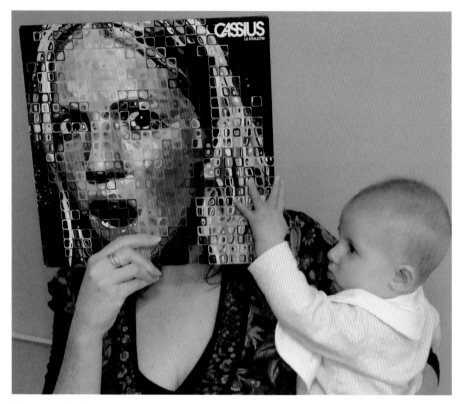

∧ **Cassius,** La Mouche, Virgin, 1999
Photograph by Adam Philpott

>> **Sesame Street,** Ernie's Hits, Pickwick, 1974
Photograph by Matthew Wagner

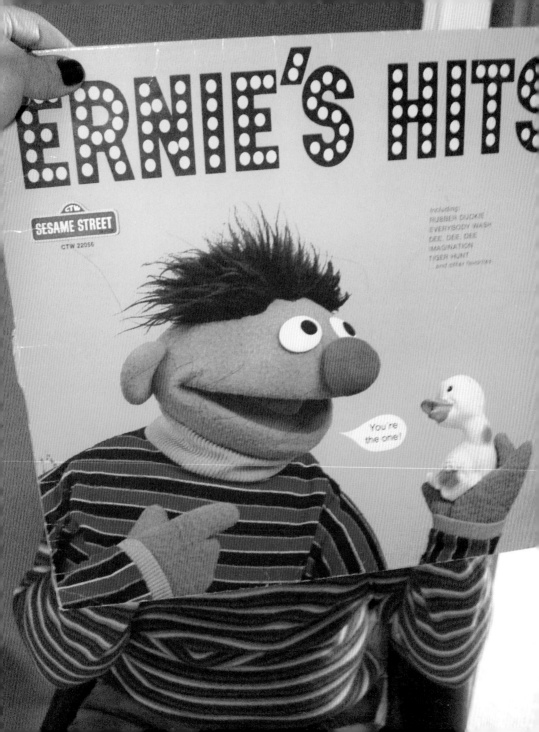

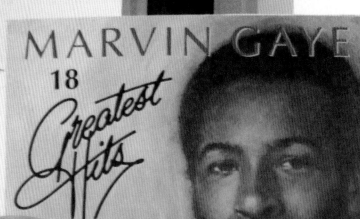

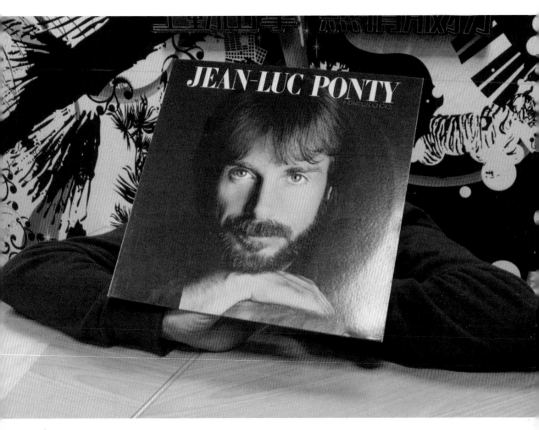

⌃ **Jean-Luc Ponty,** Individual Choice, Atlantic, 1983
Photograph by Vivian Heng and the Project Pimps

≪ **Marvin Gaye,** 18 Greatest Hits, Motown, 1988
Photograph by Steve McConville

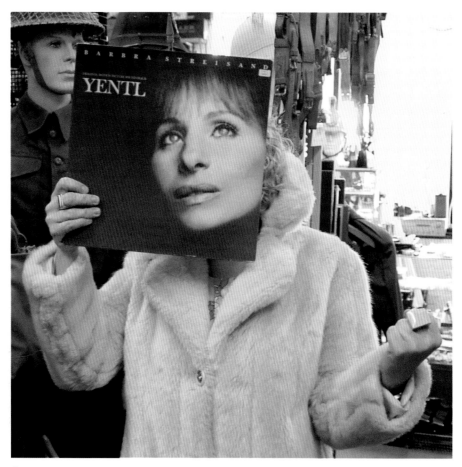

˄ Barbra Streisand, Yentl, CBS, 1986
Photograph by Lisa Heledd Jones

>> Grace Jones, Slave to the Rhythm, EMI/ZTT/Island, 1985
Photograph by Angela Bishop

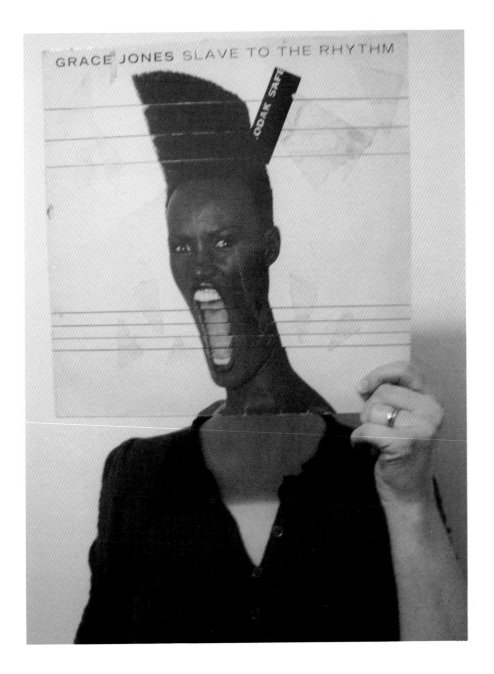

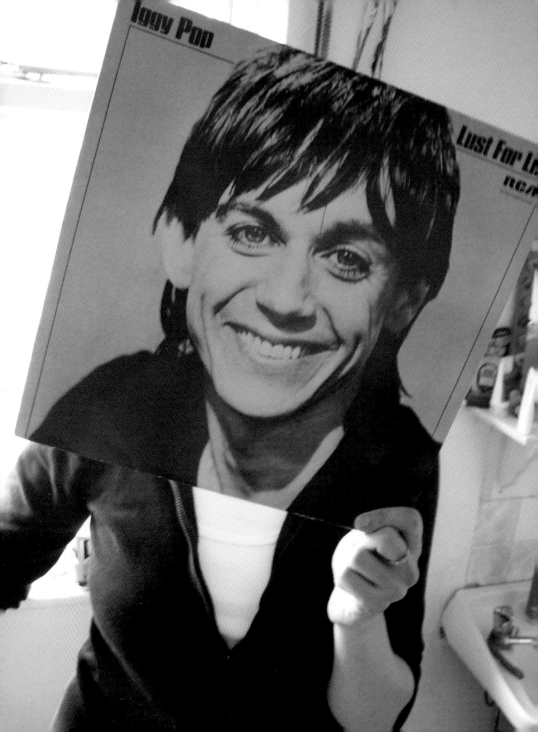

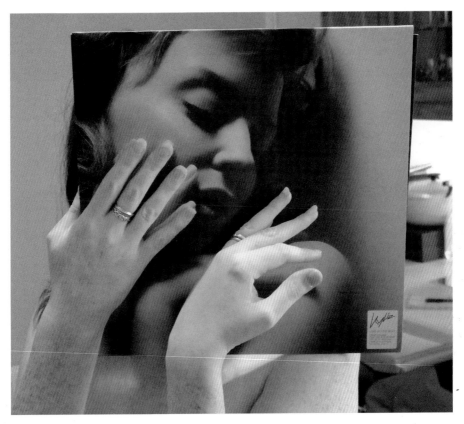

˄ **Kylie Minogue,** Love at First Sight, EMI, 2002
Photograph by Adam Philpott

<< **Iggy Pop,** Lust for Life, RCA, 1977
Photograph by Ben Valentine Trow

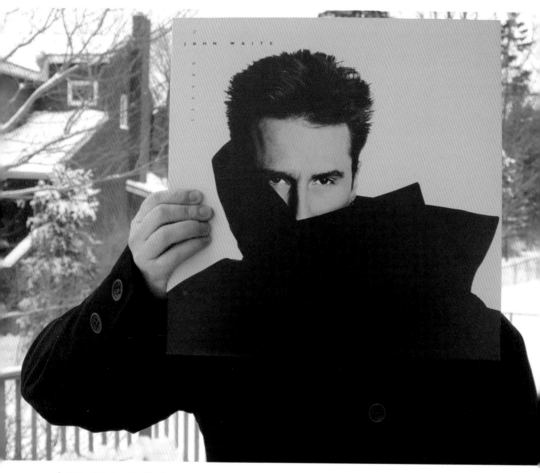

˄ **John Waite,** No Brakes, EMI, 1984
Photograph by Peter Rockwell

>> **Velvet Underground,** 1969 Velvet Underground Live with Lou Reed, Mercury, 1974
Photograph by Steve McConville

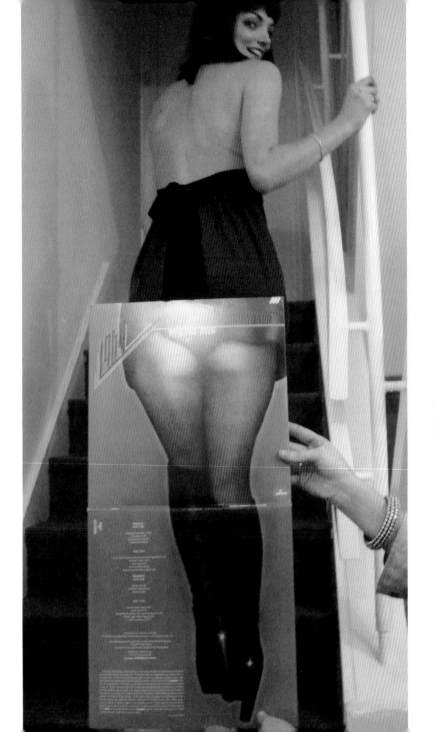

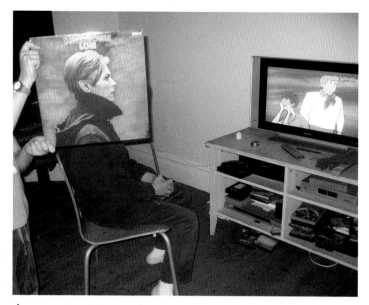

∧ **David Bowie,** Low, RCA, 1977
Photograph by Christophe Gowans

>> **Beastie Boys,** Licensed to Ill, Def Jam, 1986
Photograph by Sophie Hostick

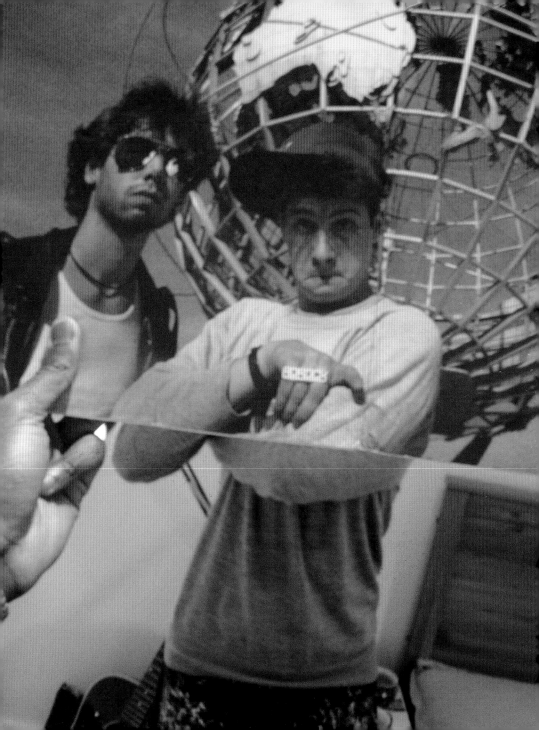

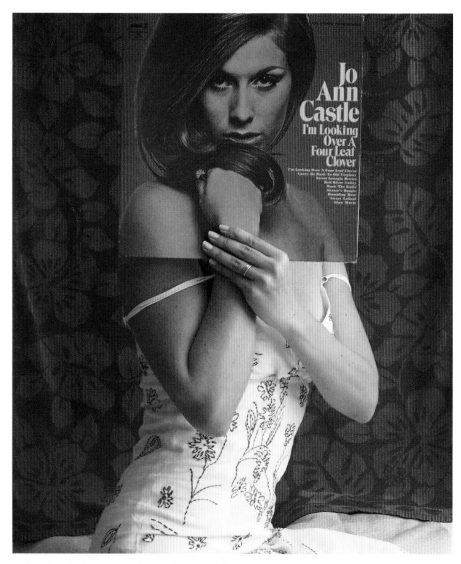

Jo Ann Castle, I'm Looking Over a Four Leaf Clover, Pickwick/33 Records, n.d.
Photograph by Annie Spencer

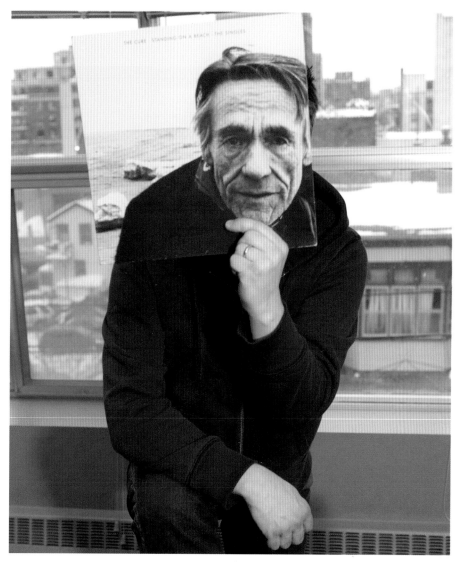

The Cure, Standing on a Beach: The Singles, Fiction, 1986
Photograph by Tom Megginson

Buffy Sainte-Marie, Moonshot, Vanguard, 1972
Photograph by Rick Hebenstreit

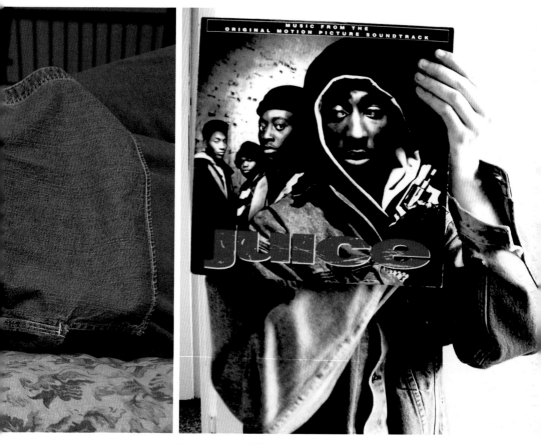

Various, Juice OST, MCA Records, 1991
Photograph by Amstersam

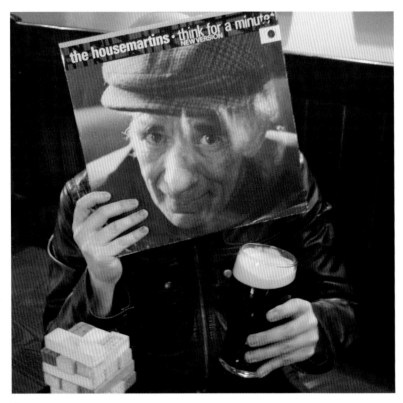

⋏ **The Housemartins,** Think for a Minute, Go! Discs, 1986
Photograph by Lisa Heledd Jones

≫ **Kris Kristofferson,** Me and Bobby McGee, CBS/Monument, 1974
Photograph by Thomas Emil Christiansen

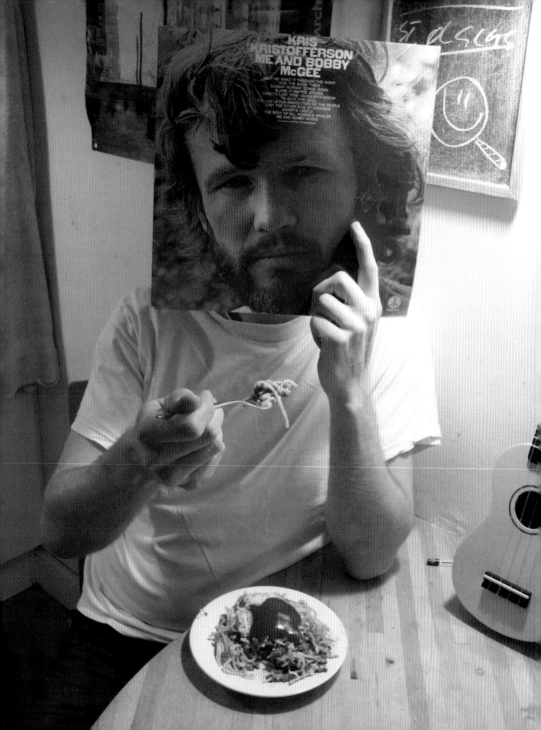

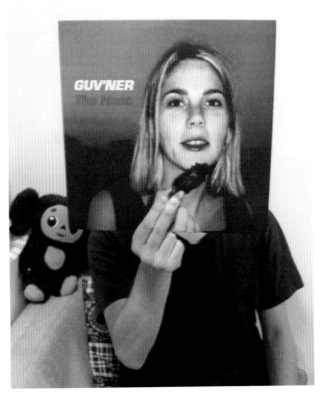

Guv'ner, The Hunt, Wiija, 1996
Photograph by Osamu Takahashi

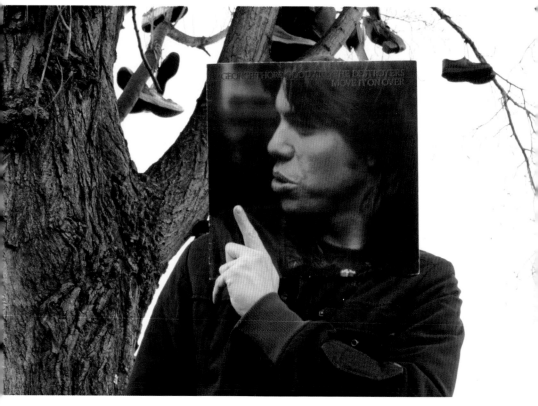

George Thorogood and the Destroyers, Move It on Over, Stockade/Attic/Sonet/Capitol/EMI, 1978
Photograph by Ewan Jones Morris and Mark Bass

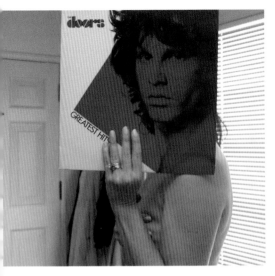

The Doors, Greatest Hits, Elektra/Asylum, 1980
Photograph by Annie Spencer

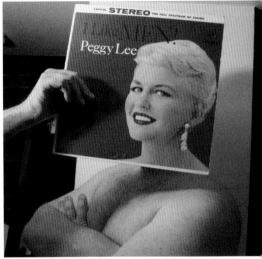

Peggy Lee, I Like Men!, Capitol, 1959
Photograph by Bill Stuart

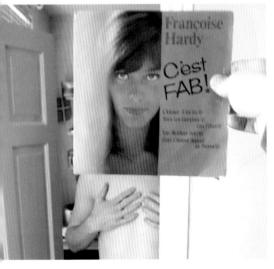

Françoise Hardy, C'est FAB!, Vogue, 1964
Photograph by Alex Dimond

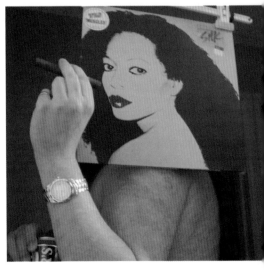

Diana Ross, Silk Electric, Capitol, 1982
Photograph by Matt Allen

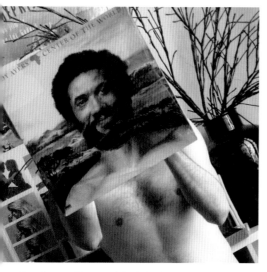

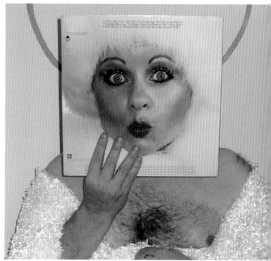

Roy Ayers, Center of the World, Polygram, 1981
Photograph by Laurent Zac

Tammy Faye, We're Blest, PLT, 1979
Photograph by Coke Brown Jr.

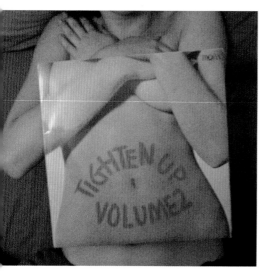

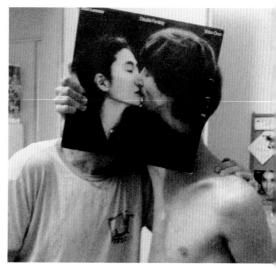

Various, Tighten Up Volume 2, Trojan, 1970
Photograph by Paul Barnett

John Lennon and Yoko Ono, Double Fantasy,
Geffen, 1980
Photograph by Leon Feldman

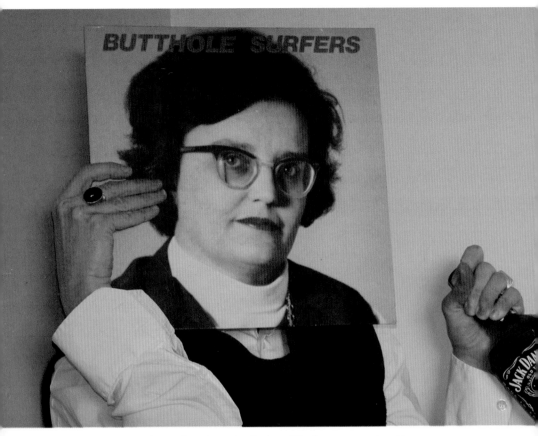

Butthole Surfers, Cream Corn from the Socket of Davis, Touch and Go, 1985
Photograph by James Odell

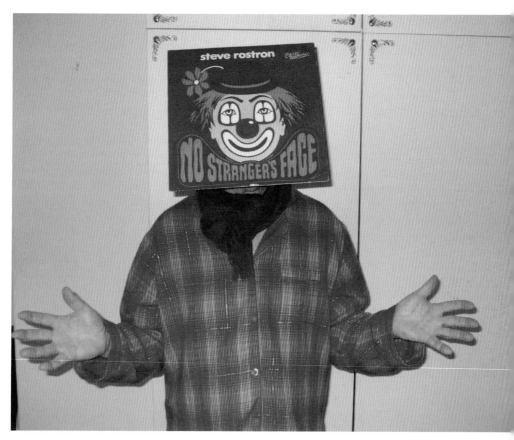

Steve Rostron, No Stranger's Face, Sweet Folk and Country, 1974
Photograph by John Rostron

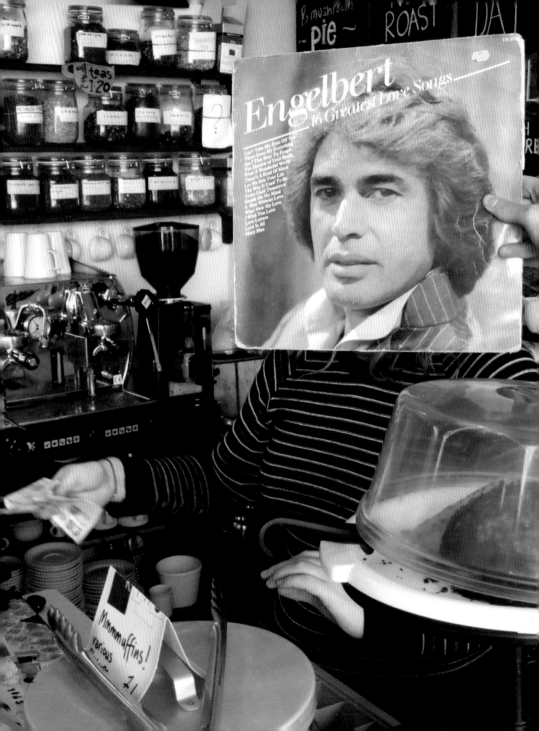

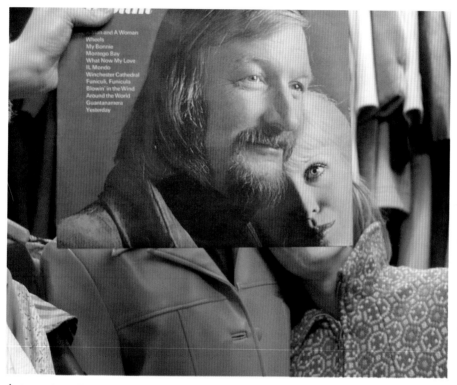

˄ **James Last,** The James Last Album, Polydor, n.d.
Photograph by Lisa Heledd Jones

<< **Engelbert Humperdinck,** 16 Greatest Love Songs, Contour, 1984
Photograph by David Hopkinson

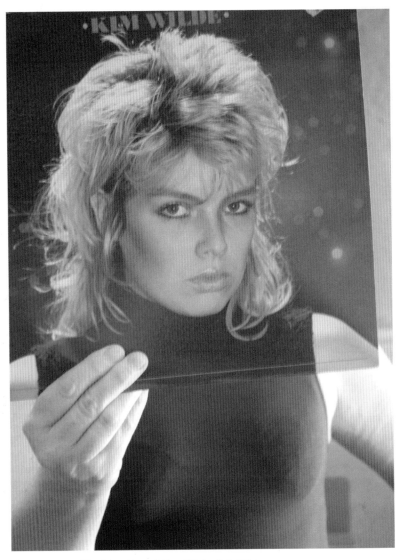

ʌ **Kim Wilde,** The Very Best of Kim Wilde, EMI, 1984
Photograph by Marcus Darbyshire

>> **Huey Lewis and the News,** Picture This, Chrysalis, 1982
Photograph by Peter Rockwell

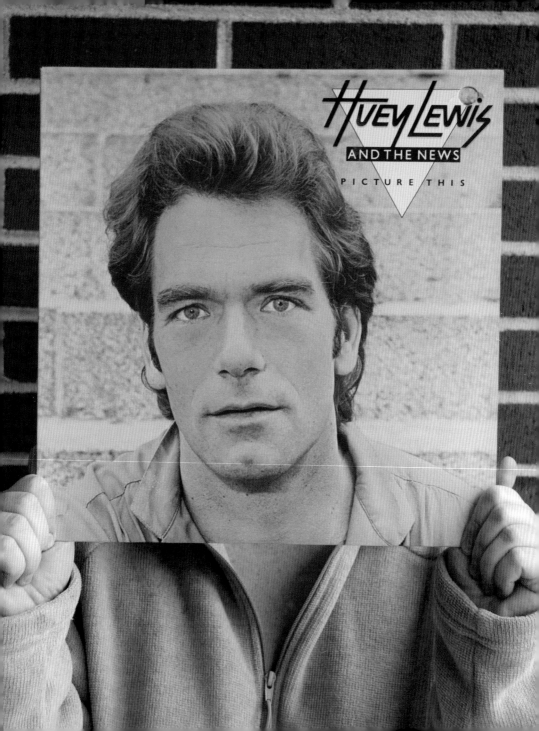

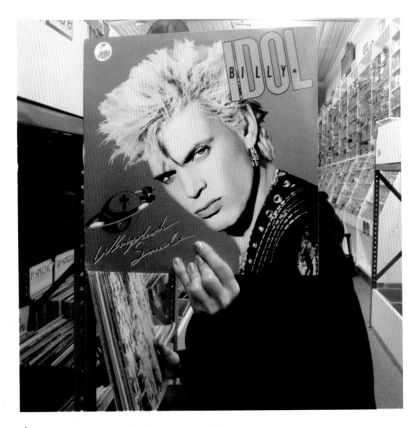

ᐱ **Billy Idol,** Whiplash Smile, Chrysalis, 1986
Photograph by Gabriel Kuo

≫ **Thin Lizzy (book),** Vagabonds, Kings, Warriors, Angels, Rar Books, 2001
Photograph by Christophe Gowans

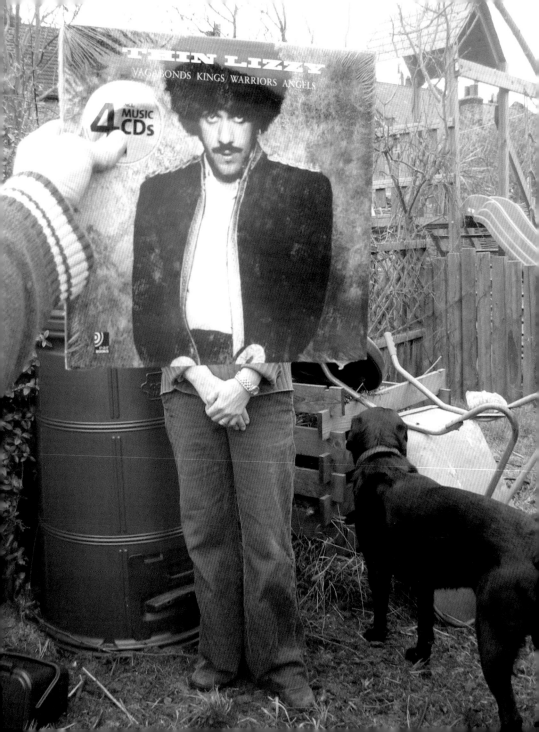

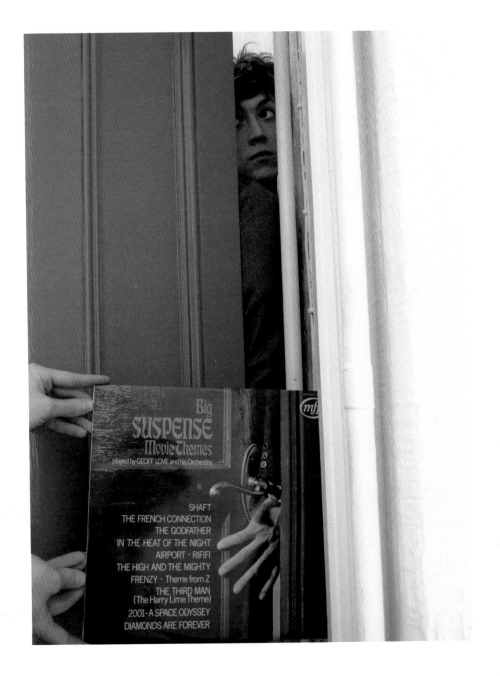

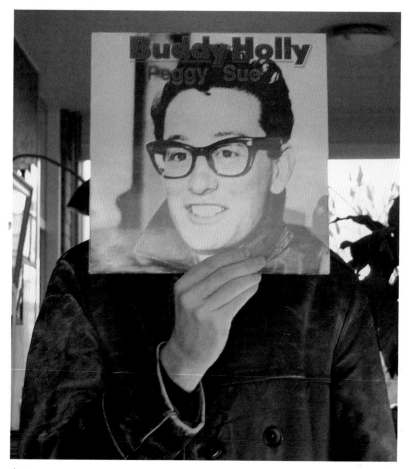

∧ **Buddy Holly,** Peggy Sue, Coral, 1957
Photograph by Henk Geuzinge

<< **Geoff Love and His Orchestra,** Big Suspense Movie Themes, Mfp, 1972
Photograph by John Rostron

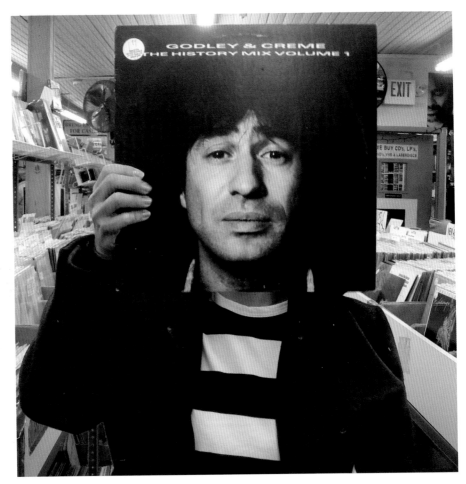

Godley and Creme, The History Mix Volume 1, Polydor, 1985
Photograph by Gabriel Kuo

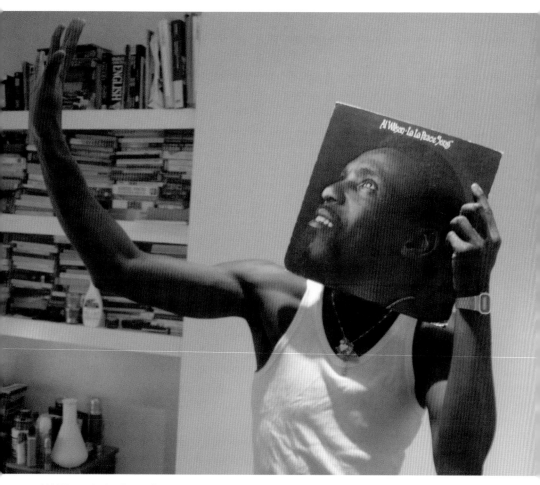

Al Wilson, La La Peace Song, Bell/Rocky Road, 1974
Photograph by Sophie Hostick

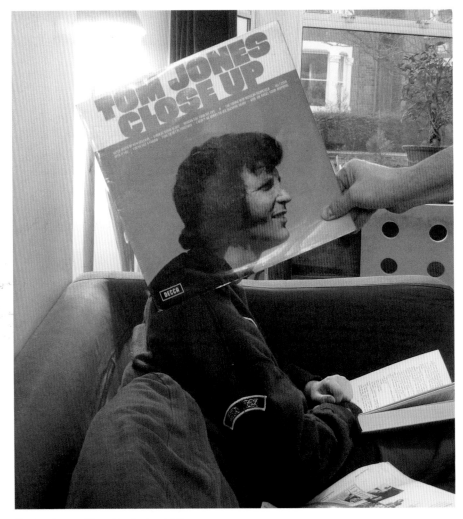

∧ **Tom Jones,** Close Up, Decca, 1972
Photograph by Christophe Gowans

≫ **Madonna,** True Blue, Sire/WEA, 1986
Photograph by David E. Brown

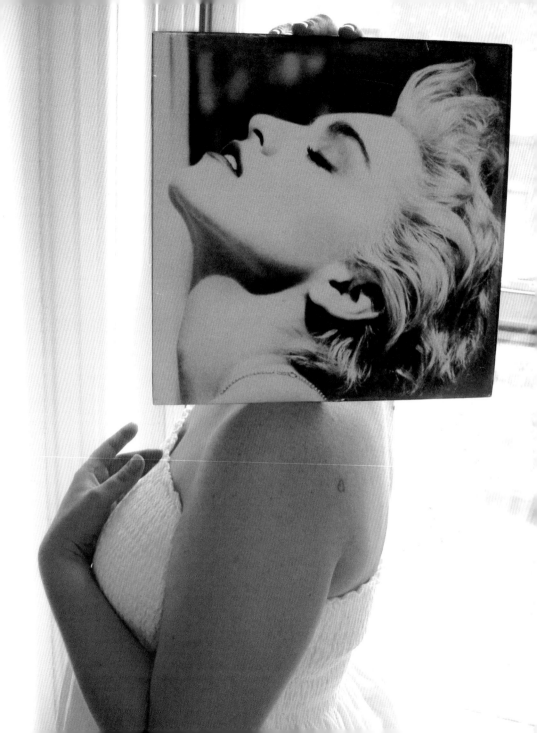

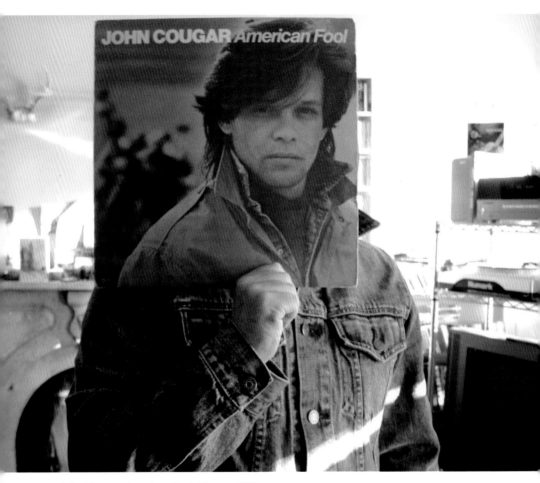

John Cougar, American Fool, **Mercury, 1982**
Photograph by Jeffrey Shay

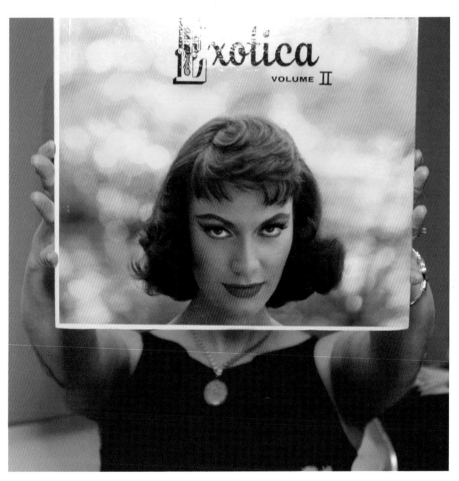

Martin Denny, Exotica Volume II, Liberty, 1957
Photograph by Christopher Minney

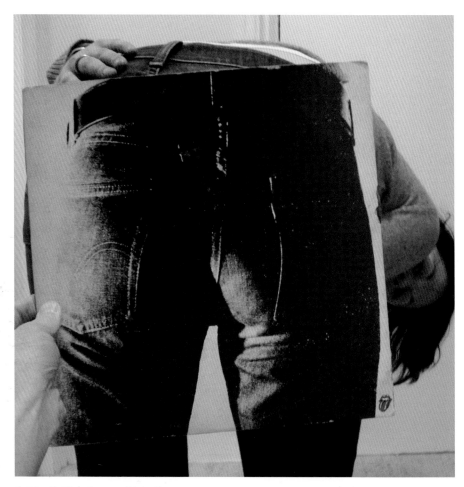

∧ **The Rolling Stones,** Sticky Fingers, **Rolling Stones Records/CBS, 1971**
Photograph by Emma Wraight

>> **Sananda Maitreya fka Terence Trent D'Arby,** Introducing the Hardline According
to Terence Trent D'Arby, **Columbia, 1987**
Photograph by Fern Miller

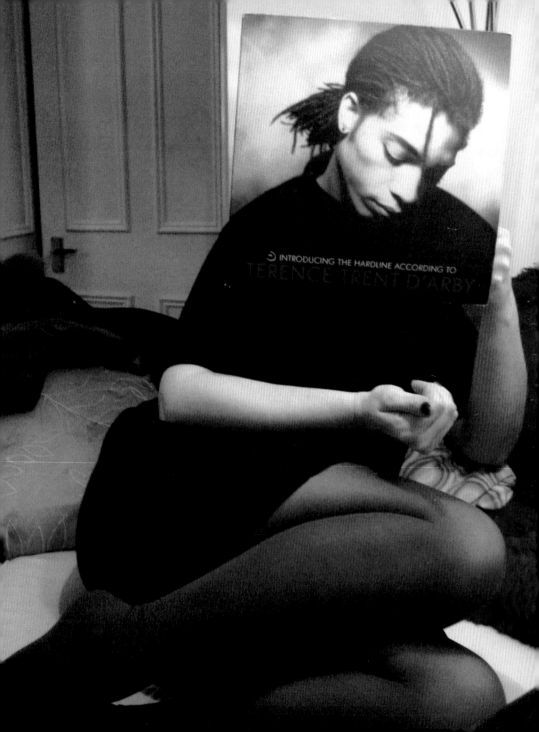

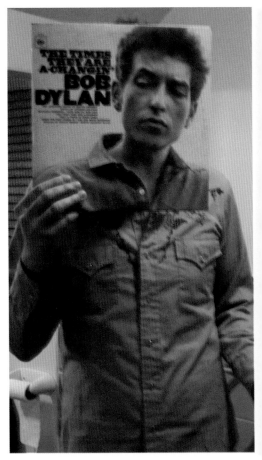

The Rolling Stones, Sticky Fingers, Rolling
Stones Records/CBS, 1971
Photograph by Lisa Heledd Jones

Bob Dylan, The Times They Are A'Changin,
CBS, 1964
Photograph by Emma Cardwell

Paul Young, The Secret of Association,
Columbia, 1985
Photograph by Michael Tran

Eurythmics, Touch, RCA, 1983
Photograph by Jonah Kagan

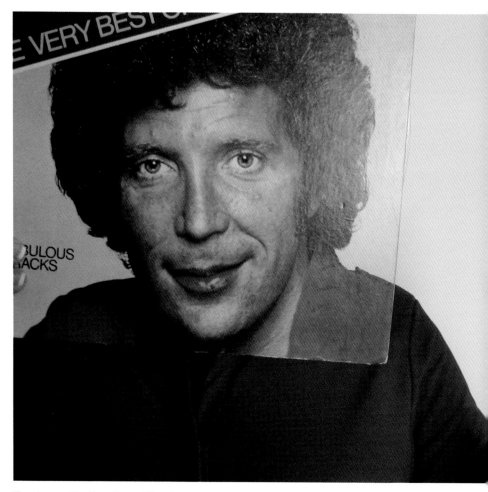

Tom Jones, The Very Best of Tom Jones, EMI, 1974
Photograph by Lena Zuniga

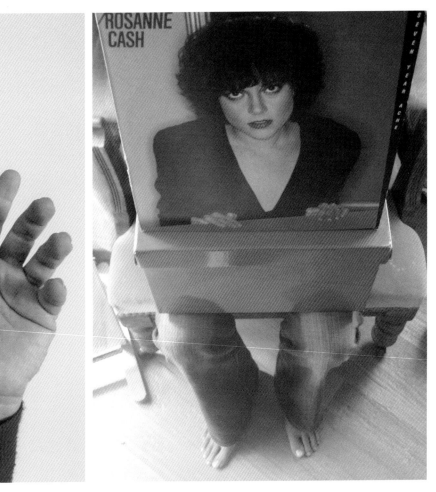

Rosanne Cash, Seven Year Ache, Columbia, 1981
Photograph by Matthew Straker

˄ **Schneider TM,** *Zoomer,* City Slang/Virgin, 2002
Photograph by Nic Finch and Debbie Savage

>> **Madonna,** The Immaculate Collection, Sire/WEA, 1990
Photograph by Sam Turley

SIDE ONE
HOLIDAY

LUCKY STAR

BORDERLINE

LIKE A VIRGIN

SIDE TWO
MATERIAL GIRL

CRAZY FOR YOU

INTO THE GROOVE

LIVE TO TELL

SIDE THREE
PAPA DON'T PREACH

OPEN YOUR HEART

LA ISLA BONITA

LIKE A PRAYER

SIDE FOUR
EXPRESS YOURSELF

CHERISH

VOGUE

JUSTIFY MY LOVE

RESCUE ME

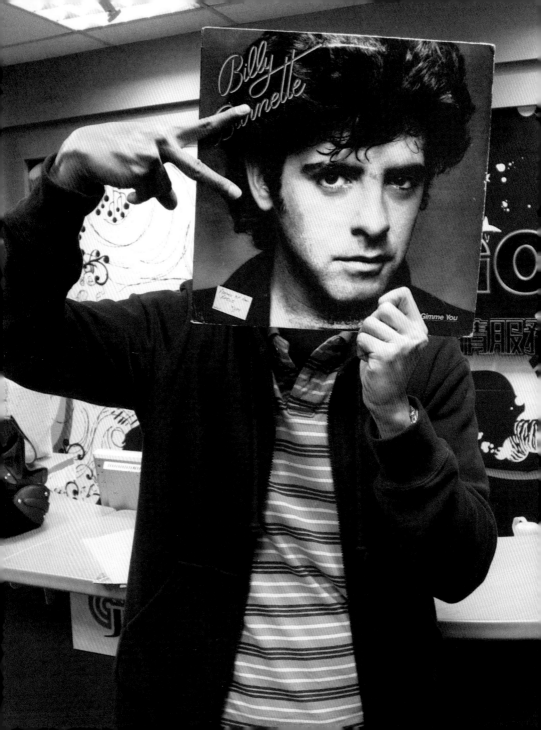

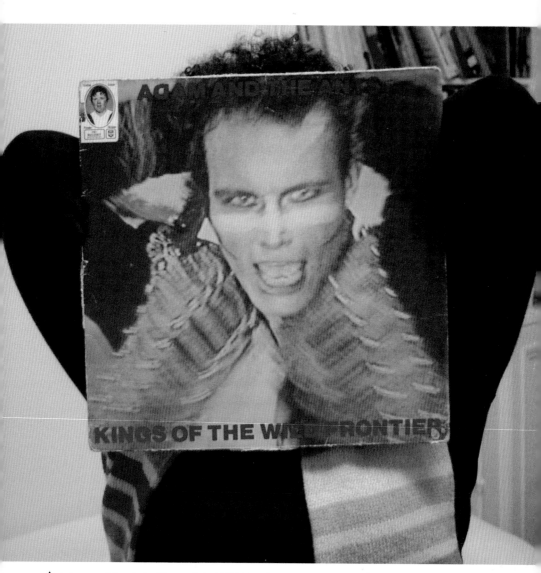

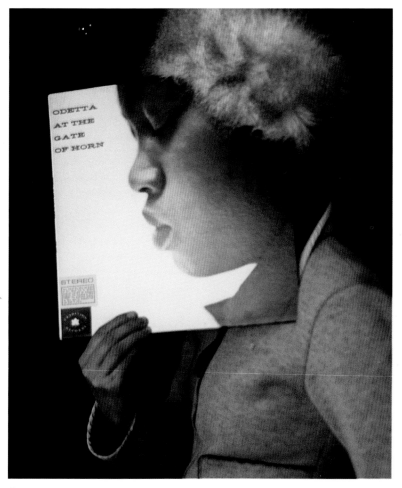

∧ **Odetta,** Odetta at the Gate of Horn, Tradition, 1957
Photograph by Martin Carr

« **Charlie Byrd,** The Look of Love, Harmony, n.d.
Photograph by Jamie Clay

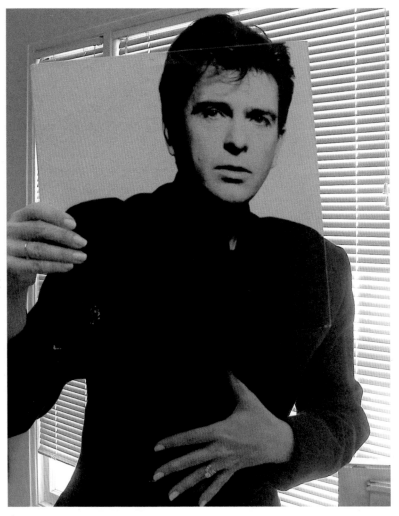

∧ **Peter Gabriel,** So, Geffen, 1986
Photograph by Annie Spencer

≫ **Patti Smith,** Horses, Arista, 1975
Photograph by Rick Hebenstreit

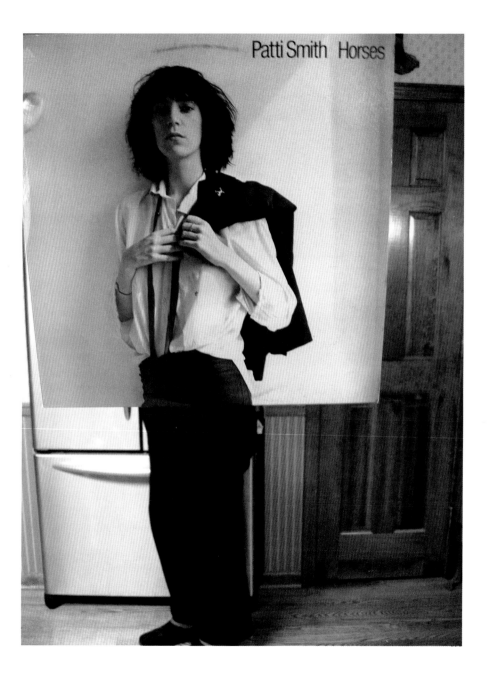

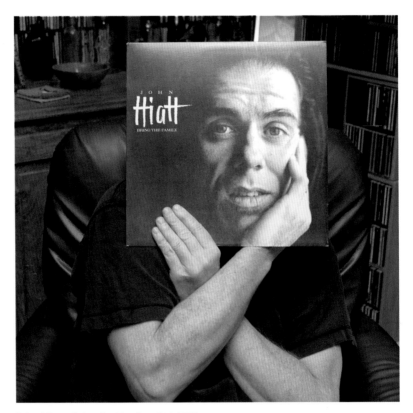

John Hiatt, Bring the Family, A&M, 1987
Photograph by Rick Hebenstreit

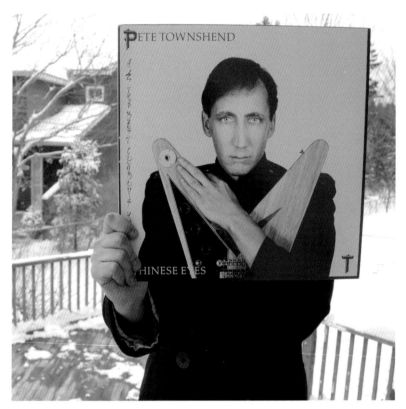

Pete Townshend, All the Best Cowboys Have Chinese Eyes, Warner Music Group, 1982
Photograph by Peter Rockwell

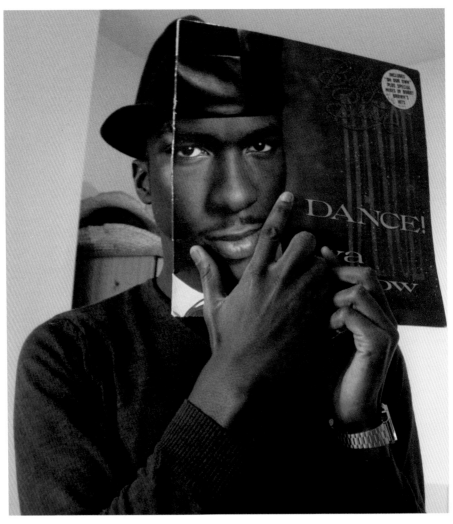

Bobby Brown, Dance! . . . Ya Know It!, MCA Records, 1989
Photograph by Sophie Hostick

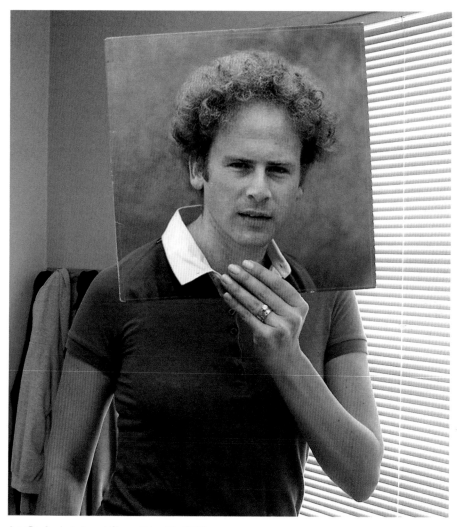

Art Garfunkel, Angel Clare, Columbia, 1973
Photograph by Annie Spencer

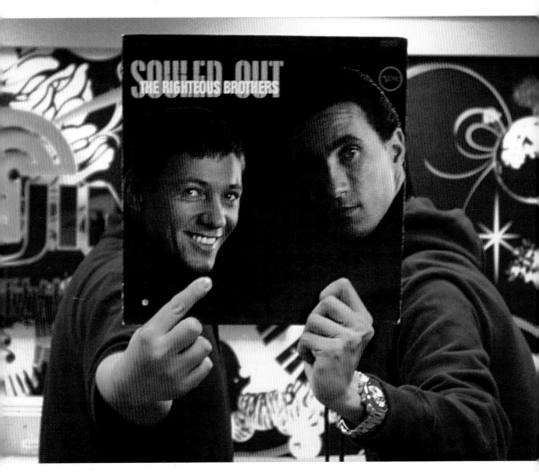

∧ **The Righteous Brothers,** Souled Out, Verve, 1967
Photograph by Vivian Heng and the Project Pimps

≫ **Anthony Quinn with The Harold Spina Singers and Orchestra,**
In My Own Way . . . I Love You, Capitol, 1970
Photograph by Thomas Emil Christiansen

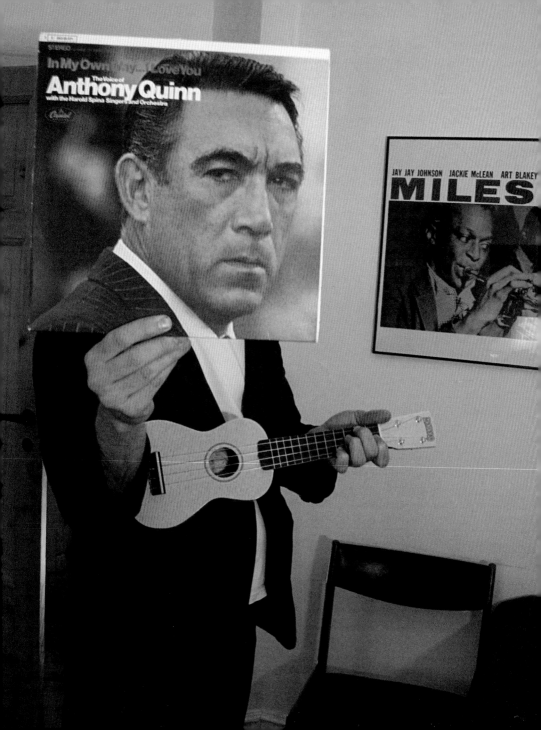

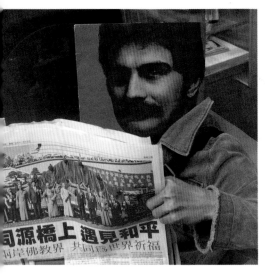

Kenny Rankin, The Kenny Rankin Album,
Atlantic/WEA, 1976
Photograph by Vivian Heng

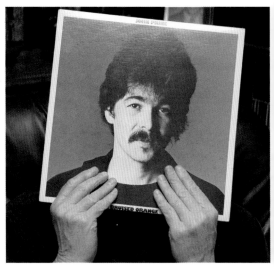

John Prine, Bruised Orange, Elektra/Asylum, 1978
Photograph by Rick Hebenstreit

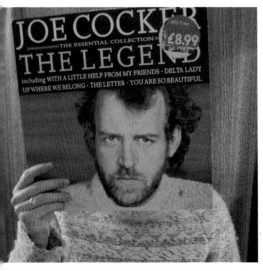

Joe Cocker, The Legend, Polygram TV, 1982
Photograph by Ben Karthauser

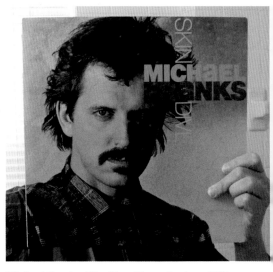

Michael Franks, Skin Dive, Warner Brothers, 1985
Photograph by Coke Brown Jr.

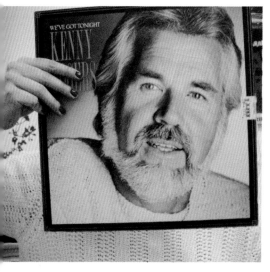

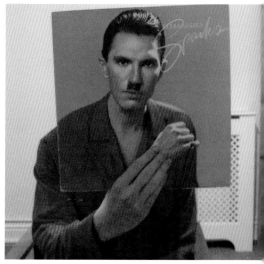

Kenny Rogers, We've Got Tonight, Razor & Tie, 1983
Photograph by Daniella Andreucci

Sparks, Introducing Sparks, CBS, 1977
Photograph by Russell Peake

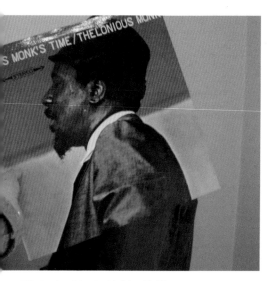

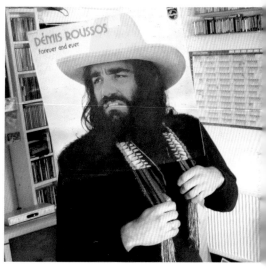

Thelonius Monk, It's Monk's Time, Columbia, 1964
Photograph by Emma Wraight

Demis Roussos, Forever and Ever, Philips, 1973
Photograph by David Hopkinson

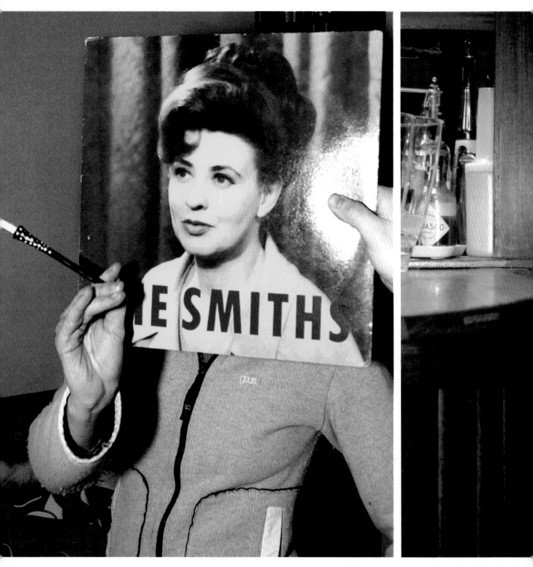

The Smiths, Shakespeare's Sister, Rough Trade, 1985
Photograph by Martin Carr

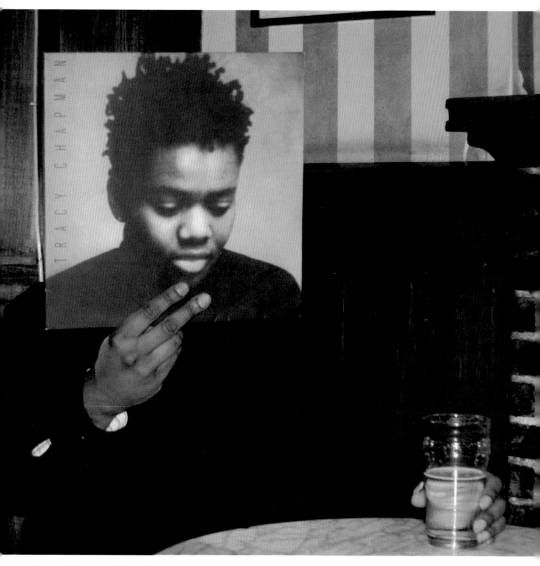

Tracy Chapman, Tracy Chapman, Elektra, 1988
Photograph by Ewan Jones Morris and Mark Bass

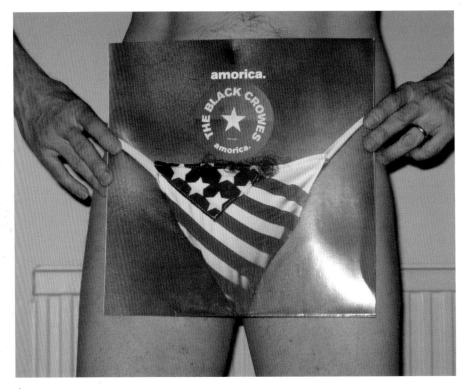

∧ **The Black Crowes,** Amorica, American, 1994
Photograph by Iain Colville

>> **Nana Mouskouri,** The Delightful Nana Mouskouri, Fontana, 1973
Photograph by Peter Shanks

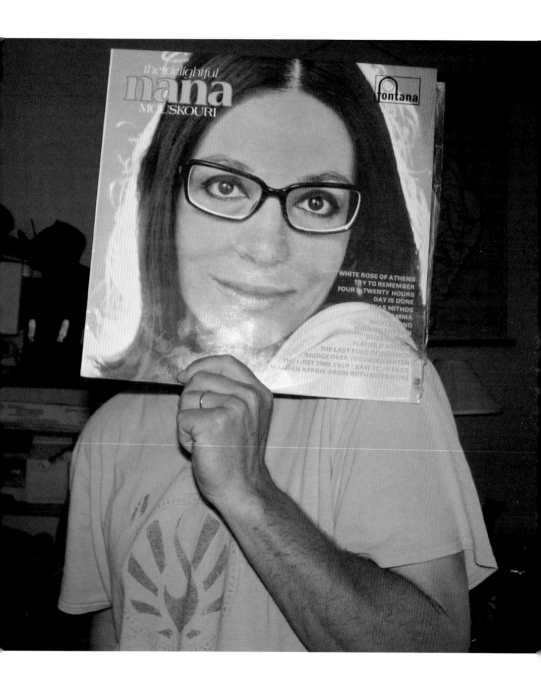

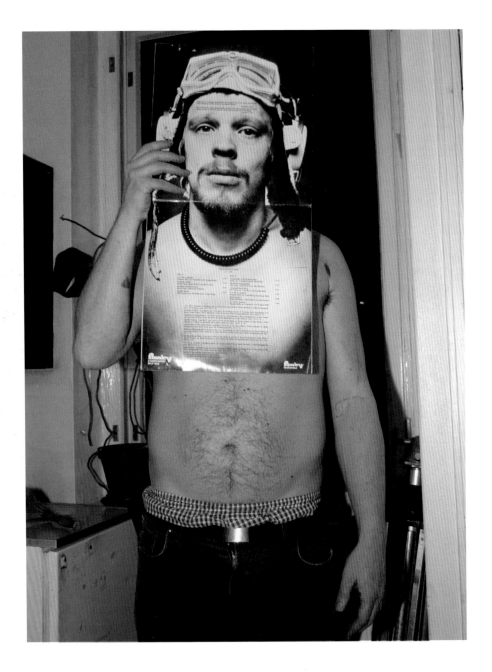

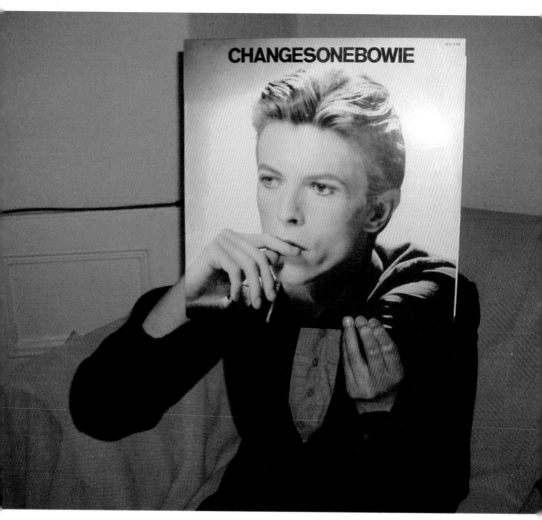

∧ **David Bowie,** Changes One, RCA, 1976
Photograph by Ian Watson

≪ **Vesa-Matti Loiri,** 4+20, Finnlevy, 1971
Photograph by Samuli Raita

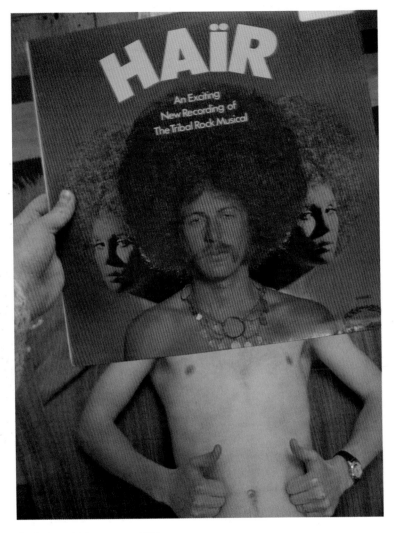

⌃ **Various,** Hair, Hallmark, 1970
Photograph by Ben Karthauser

>> **Jermaine Jackson,** Do You Remember Me?, Arista, 1986
Photograph by Henry Covey

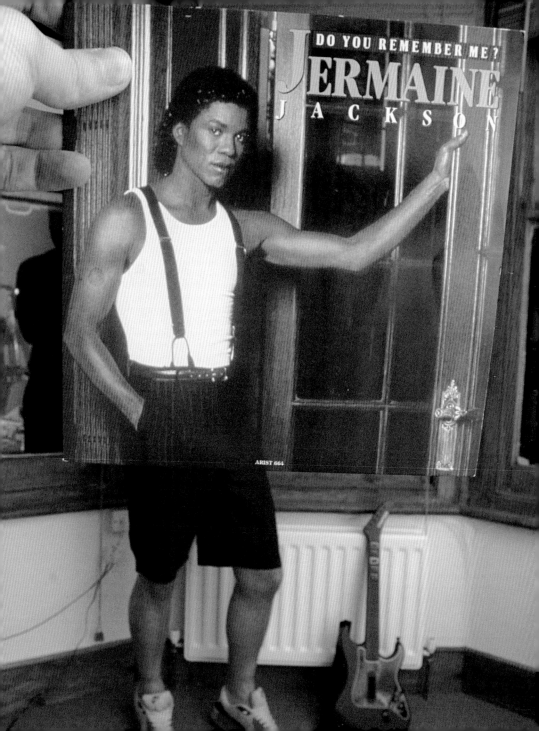

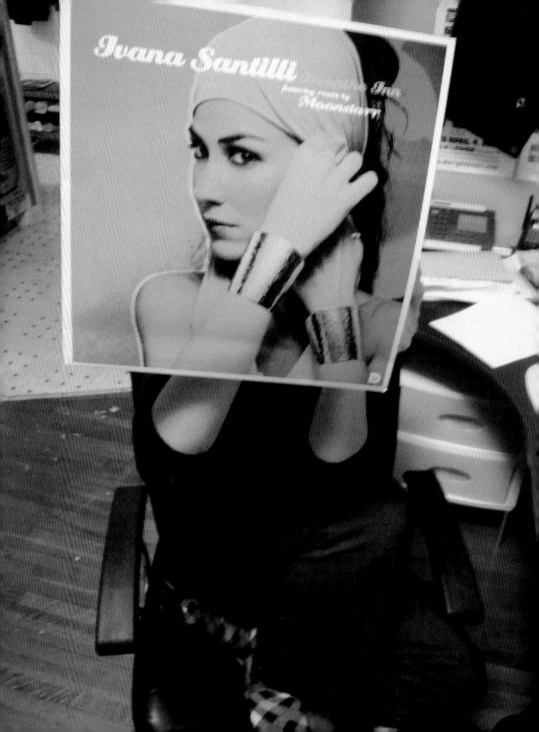

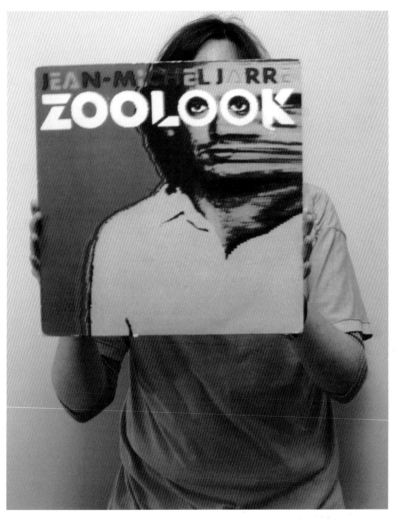

∧ Jean-Michel Jarre, Zoolook, Dreyfus/Polydor, 1984
 Photograph by Nic Finch and Debbie Savage

<< Ivana Santilli, Breathe Inn (Moonstarr remix), Do Right! Music, 2005
 Photograph by John Kong

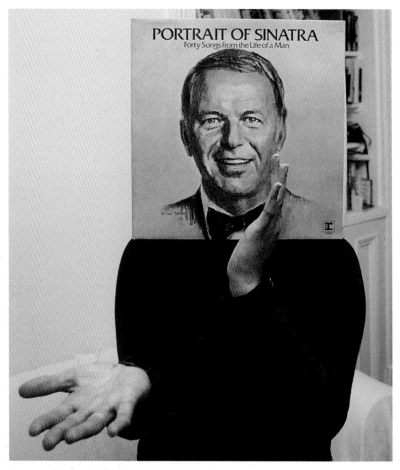

∧ **Frank Sinatra,** Portrait of Sinatra: Forty Songs from the Life of a Man, WEA, n.d.
Photograph by John Rushton

>> **The Smiths,** Sheila Take a Bow, Rough Trade, 1987
Photograph by Ben Potter

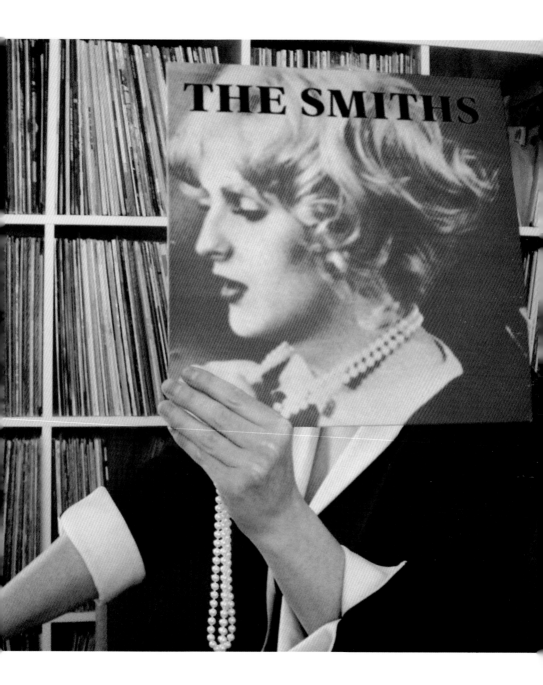

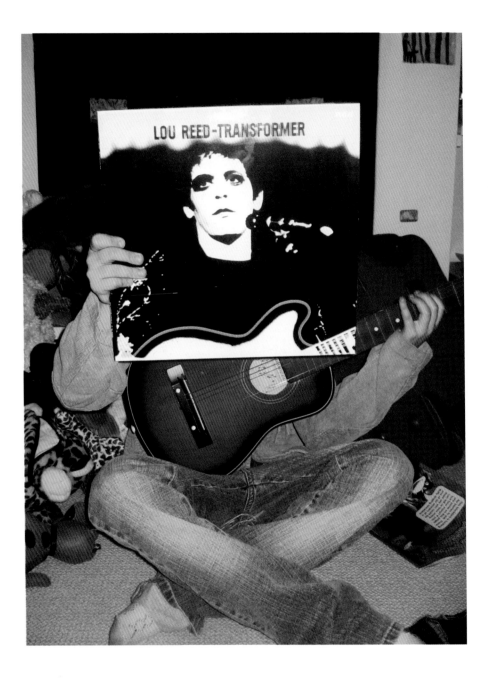

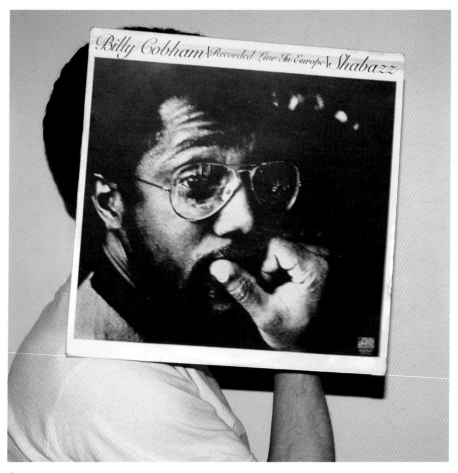

˄˄ **Billy Cobham,** Shabazz, Atlantic / WEA, 1975
Photograph by Nic Finch and Debbie Savage

<< **Lou Reed,** Transformer, RCA, 1972
Photograph by Christophe Gowans

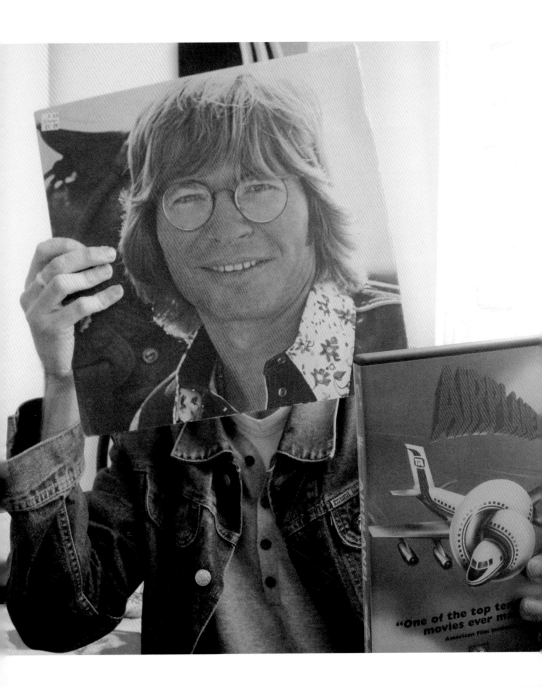

"One of the top ten
movies ever ma
American Film In

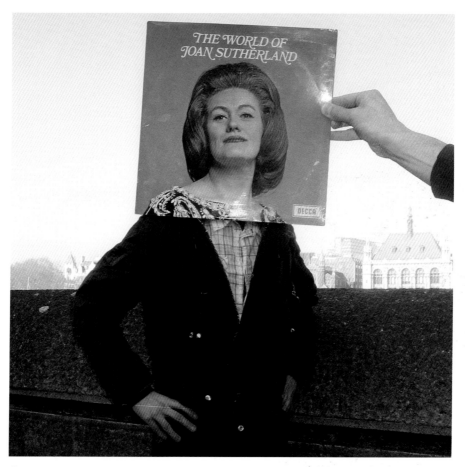

ʌ **Joan Sutherland,** The World of Joan Sutherland, Decca, 1970
Photograph by Christophe Gowans

<< **John Denver,** Windsongs, RCA, 1975
Photograph by Lee Cooper

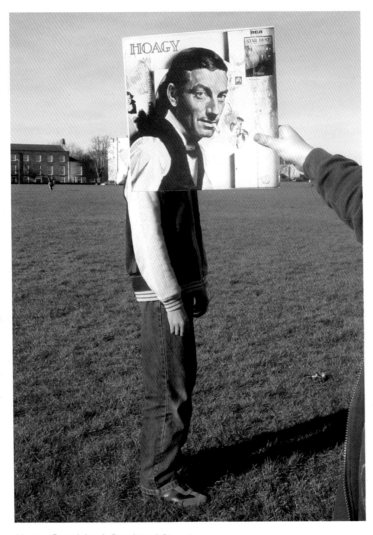

Hoagy Carmichael, Stardust, RCA, n.d.
Photograph by Christophe Gowans

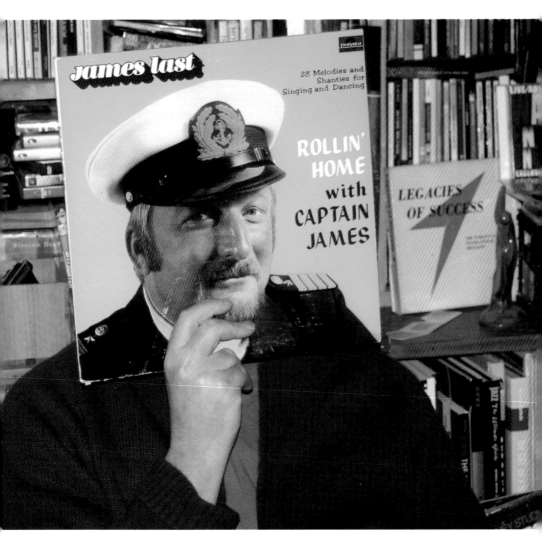

James Last, Rollin' Home with Captain James, Polydor, n.d.
Photograph by Jamie Clay

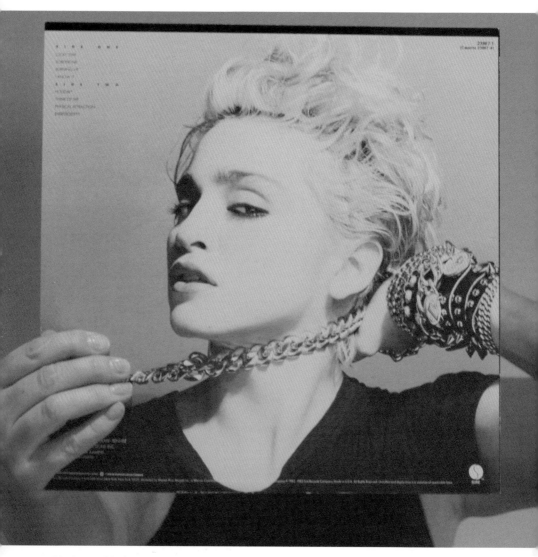

Madonna, Madonna, Sire/WEA, 1983
Photograph by Marcus Darbyshire

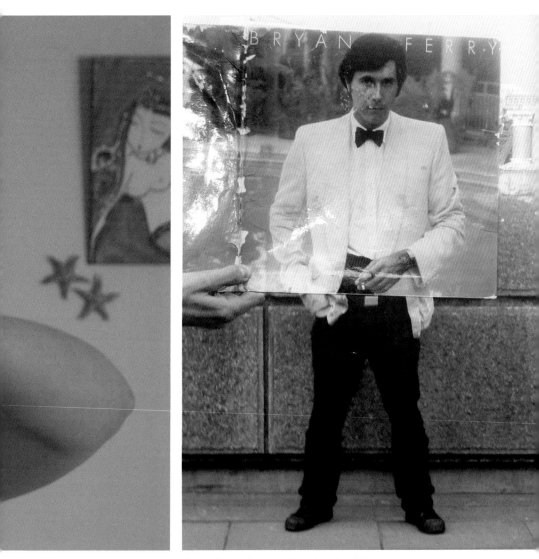

Bryan Ferry, Another Time Another Place, Virgin, 1974
Photograph by Christophe Gowans

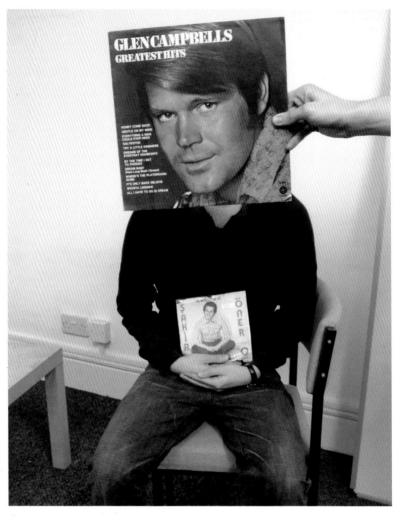

ʌ **Glen Campbell,** Glen Campbell's Greatest Hits, EMI, n.d.
Photograph by John Rostron

>> **Pam Ayres,** Some of Me Poems and Songs, Galaxy, 1976
Photograph by David Hopkinson

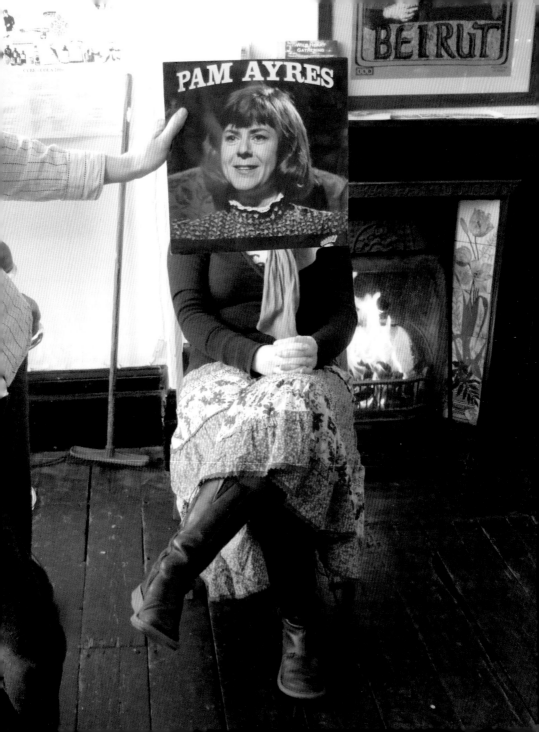

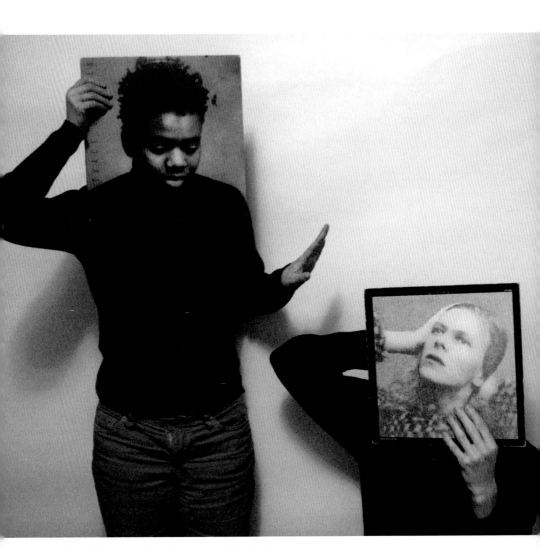

Tracy Chapman, Tracy Chapman, Elektra, 1988

David Bowie, Hunky Dory, RCA, 1979
Photograph by Mark Del Lima

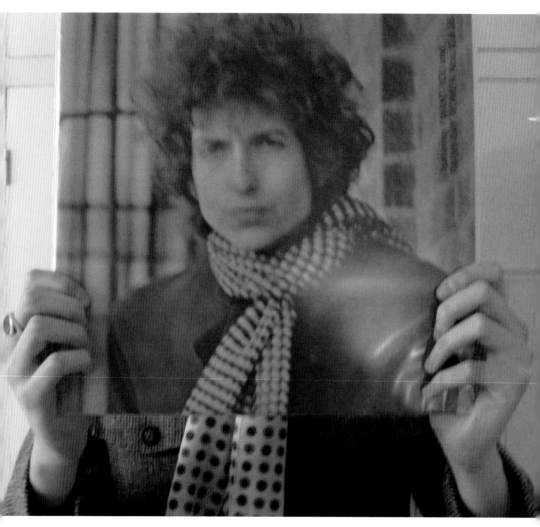

Bob Dylan, Blonde on Blonde, Columbia, 1967
Photograph by Michael West

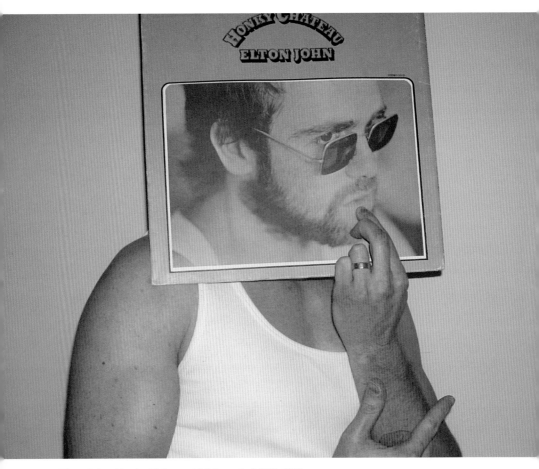

Elton John, Honky Château, UNI Records (MCA), 1972
Photograph by Ian Doreian

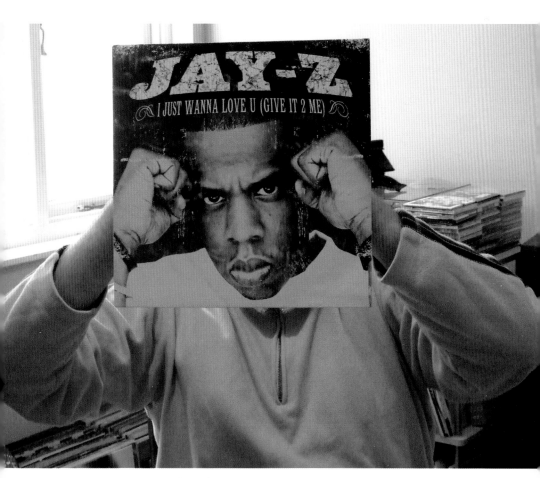

Jay-Z, I Just Wanna Love U (Give It 2 Me), Def Jam/Universal, 2000
Photograph by Adam Philpott

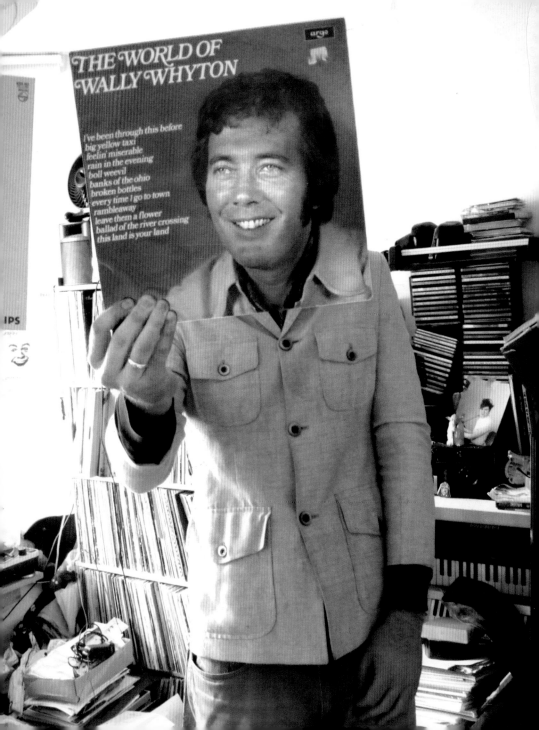

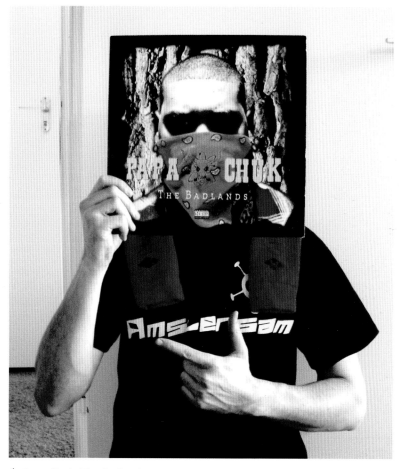

⌃ **Papa Chuk,** The Badlands, Pendulum, 1994
Photograph by Amstersam

≪ **Wally Whyton,** The World of Wally Whyton, Argo, 1972
Photograph by David Hopkinson

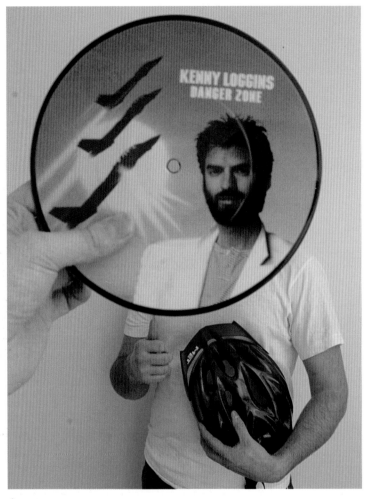

ʌ **Kenny Loggins,** Danger Zone, CBS, 1986
 Photograph by Henry Covey

>> **Bonnie Tyler,** Faster Than the Speed of Night, CBS, 1983
 Photograph by Vivian Heng and the Project Pimps

The Sundays, Goodbye, Parlophone, 1992
Photograph by Jutta Paavolainen

ACKNOWLEDGMENTS

Each photo has a credit but this is for other notable faces who have helped us along the way:

The staff at Artisan, Beth Abell, Mike Barnett, Paul Barnett, Anna Berns, Andy Best, Laura Brown @ Russells, Gordon Charlton, Jon Clee for always TCB, Clwb Ifor Bach (Cardiff), Matt Cresswell, Andy Davidson, Anette Dal Jensen, Marcel Duchamp, Anna Ellis, Huw Evans, Nic Finch, Amy Fleming, Marc Gerald, Stephen Godfroy, Carl Gosling and The Social W1, Christophe Gowans, Mike "Pops" Hyde, Sheenagh and Mark James, Tomos Jones, Kellys Records (Cardiff), Christian Marclay, the Morris and Eunson families, Mei Lewis at Mission Photographic, Lisa Heledd Jones, Anna-Marie McMahon, René Magritte, Ewan Jones Morris, Iain Peebles, The Point (Cardiff), Jon Pountney at Maximum Attack, Casey Raymond, Leah Roberts, Paul Ross, the Rostron, Mcquillan, and Barben families, Carl Rylatt, Siarc Marw, Sister Ray (London), Sleeveface Facebook group, Sleeveface Flickr group, Tim Snell, Alex Steinweiss, Huw Stephens, Sarah Stephens, Paolo di Terlizzi at Refresh Creative, Charlotte Taylor, Truckers of Husk, Uned 5, Paul Ward, and Chris Watts.

CARL MORRIS (left), who is one day older than MTV, discovered the joys of Sleeveface while DJing with the Paul McCartney solo record *McCartney II*. He runs the My Kung Fu record label by day and his favorite song is usually the first track on side B.

JOHN ROSTRON (right) runs Plug Two, a music promotions and artist management company. He cofounded the My Kung Fu record label, manages U.S. singer Marissa Nadler, and is the live agent for the U.K.'s Cerys Matthews. He promotes hundreds of live music concerts every year.

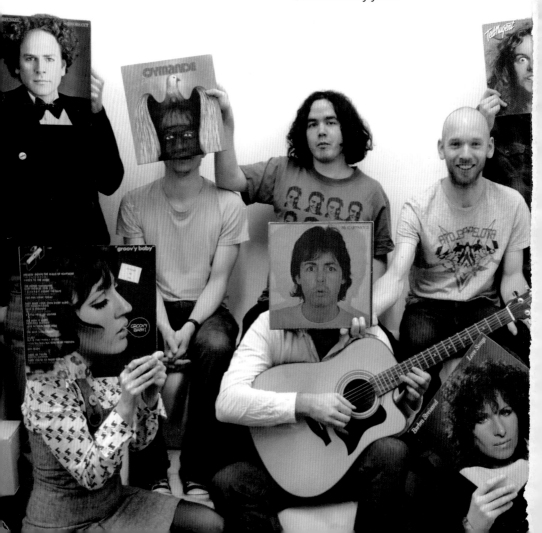